THE ARTIST'S
PAINTING LIBRARY

PORTRAITS AND FIGURES IN WATERCOLOR

BY CHARLES REID
FOREWORD BY WENDON BLAKE

WATSON-GUPTILL PUBLICATIONS/NEW YORK

Copyright © 1984 by Billboard Ltd.

First published 1984 in New York by Watson-Guptill Publications,
a division of Billboard Publications, Inc.,
1515 Broadway, New York, N.Y. 10036

Library of Congress Cataloging in Publication Data
Reid, Charles, 1937-
 Portraits and figures in watercolor.
 Includes index.
 1. Portraits. 2. Human figure in art. 3. Water-
color painting—Technique. I. Title.
ND2200.R45 1984 751.42'242 84-2350
ISBN 0-8230-4096-8

Distributed in the United Kingdom by Phaidon Press Ltd., Littlegate
House, St. Ebbe's St., Oxford

Printed in Malaysia

6 7 / 94

CONTENTS

Portraits and Figures in Watercolor. When most painters hear the words "portrait" or "figure study," they think of an oil painting or perhaps a pastel, but rarely a watercolor. Thus, Charles Reid's beautiful book will surprise and inspire many readers by demonstrating that watercolor is a wonderful medium for painting portraits and figures. As you turn these pages, you'll discover that the translucency of watercolor is ideally suited to the job of capturing the delicate lights and shadows on faces and figures, and especially the glowing tones of human skin. And once you try painting portraits, clothed figures, and nudes in watercolor, I think you'll be exhilarated by the discovery that this rapid, spontaneous medium enables you to capture an extraordinary variety of fleeting effects with delightful speed. The shape of a shadow on a face, a flash of light on the hair, the characteristic stance of the model, an unexpected burst of color in the model's skin or clothing —all these can suddenly appear on the watercolor paper with a few washes or strokes of fluid color.

Portrait Painting Basics. Although most of the demonstrations in this book are in color, the author believes that a successful portrait is based on a careful study of values. So he begins with a series of simple demonstrations in black-and-white washes, emphasizing form, light, and shade. Reid begins by showing how to paint a basic head form in a series of simple washes. Then he demonstrates how to paint each of the features: eyes, nose, mouth, and ears. You'll find two demonstrations that show you how to paint hair, light and dark. And this review of the basics concludes with two demonstrations that show you how to paint hands.

Figure Painting Basics. Turning to the fundamentals of figure painting, Reid emphasizes the importance of rendering the total shape of the figure in just a few values, placed on the paper with big, decisive strokes and washes. He starts out by demonstrating how to paint a simple standing figure in just two values—one for the light and one for the shade. In a second demonstration, the author shows how to apply this painting method to recording the specific shapes of the figure with greater precision. Then he moves on to a demonstration in which he paints a figure in three values. And he concludes with a four-value demonstration that shows you how to record a full tonal range with the greatest possible simplicity and directness.

Portraits in Color. Reid starts his color section with a brief look at color mixing, exploring various color combinations for different skin tones. You then watch over his shoulder as he demonstrates a series of simple portrait heads—closeups of various faces with minimal backgrounds. The first four demonstrations are a three-quarter view of a woman's head, a front view of a small child's head, another front view of an older boy's head, and a profile of a bearded man. The author then moves on to demonstrate more ambitious portraits: a side view of a seated male sitter; a front view of a female model in an outdoor setting; another female model shown in a three-quarter pose indoors; and finally a group of figures.

Figures in Color. The author's first figure demonstration in color—a frontal, standing pose—takes you back to the basics once again, this time showing you how to paint a complete figure in large, simple washes that record the big shapes of light and shade. Reid then demonstrates how to put this simple technique to work in a complete figure painting that records form, light, and shade, with more specific attention to detail. You then watch him paint a series of figures in various poses, settings, and color combinations: a back view of a standing figure; a back view of a seated figure; another seated figure, this time seen from the side; a reclining figure in an outdoor setting; and a reclining figure indoors.

Closeups in Color. Scattered throughout these color demonstrations are dramatic closeups of Reid's portrait and figure paintings in watercolor, showing how he uses the brush and fluid color to capture details of heads and features, hair, clothing, skin tones, props and backgrounds. Many of these closeups are shown in the actual size of the paintings themselves.

Simplicity, Spontaneity, and Logic. Reid's command of watercolor is dazzling, and he paints faces, bodies, clothing, and backgrounds with enviable freedom and vivacity. But he makes clear that there's an underlying logic to the splashy pleasures of watercolor. Above all, he shows you how to visualize your subject in a few big areas of light, shade, and color. He shows you how to think and paint simply. And he demonstrates that every watercolor is essentially logical, proceeding in a series of steps that are the result of clear thinking and solid planning.

WENDON BLAKE

About the only unpleasant task of painting with watercolor is going out to the art store to buy the necessary materials. Good watercolor brushes, paper, and colors are very expensive. The only thing I can say about this is that good materials are an excellent investment. Try to steel yourself against the expense, knowing that you just can't do your best work if you use poor materials.

Brushes. There are two main types of brushes, ox-hair and sable. Sable brushes are the best, but they come in varying qualities. You should buy as good a brush as you can possibly afford. The three sable brushes I suggest are a 1″ flat, a Number 10 round, and a small, Number 3 or Number 4 round. The numbering of brushes seems to differ from one manufacturer to another. For example, the Winsor & Newton 8 is approximately the same size as the Grumbacher Number 10. Investigate these differences yourself, and choose the brushes you feel most comfortable with.

Paper. Good watercolor paper is very important. By "good" I mean a paper that's fairly soft and absorbent. Cheaper papers tend to be hard, often repel the paint, and sometimes have an oily film that doesn't take the color well. However, you can certainly use a cheaper paper until you have a good idea of how watercolor works.

Watercolor paper comes in various weights and textures. The textures run from very smooth, called hot-pressed, to rougher textures, called cold-pressed (moderately irregular) and rough (which means *really* rough). I suggest that you use a fairly smooth texture like hot-pressed, although later you should experiment with both rough and smooth paper and see which you really like best.

Hot-pressed, cold-pressed, and rough papers come in weights running from the very light 72 lb. to the medium weight 140 lb. to the very heavy 300 lb. The weight of a particular paper means the number of pounds that a ream (500 sheets) of that paper weighs. The paper is normally the standard Imperial size—22″ x 30″ (56 x 76 cm). The 72 lb. paper is really too thin and light for watercolor work, unless you don't plan to make any mistakes. The heavier paper, such as 140 lb. or—even better—300 lb. takes more punishment. The 300 lb. paper is especially good to use. You'll find you can make all the corrections you want on it without fear of its buckling—becoming wavy. *Don't* buy "all-purpose" papers that purport to be good for all mediums. They're horrible and literally impossible to do a decent picture on.

Paintbox and Palette. Since you'll probably do most of your watercolor work indoors, it doesn't really matter what you carry your paints and brushes in. A fisherman's tackle box or a carpenter's tool box makes a very handy container for all of your equipment. Both types of boxes have small compartments that are excellent for holding paint tubes and brushes, and the large compartment beneath is a good place for your palette and water container.

Don't buy a palette that has ready-made cakes of dry color in it—buy one that's meant for tube colors. And don't buy plastic palettes. They don't last and it's difficult to mix pigment and water on them.

Miscellaneous. I always have a kneaded eraser, pencils, and a razor blade in my box. Never use a hard, office type eraser and, even when you use a soft eraser such as a kneaded, be careful not to overdo your corrections. If you scrape the surface of the paper, it will become rough, it won't hold the paint as well as it should, and the rough texture of the erased area will show through your paint.

Use a 2B office pencil. It's fairly soft, but not too soft. Hard pencils tend to dig up the paper and, although they make very nice light lines, I think you'll find yourself bearing down as you try to develop your drawings. Very soft pencils, such as 4B or 6B, tend to leave very dark lines that become bothersome at the painting stage.

Razor blades are very useful for scratching out light areas when a painting is dry. You can also use razor blades to scratch out when your painting is wet, but be careful not to dig up the paper.

For water containers, I use plastic jars—the kind that margarine comes in. They fit nicely in my paintbox and they don't break.

I use pushpins to attach my paper to my drawing board—unless I'm using a Masonite board. In that case, I keep a roll of 1″ masking tape handy to fasten my paper to the board.

Finally, I always carry a box of facial tissues. They're excellent for blotting brushes and areas of paintings that are too wet and are getting out of control. I also use them to scrub out mistakes and to soften the edges that have become too hard.

Step 1. For the sake of variety, we'll do a three-quarter view head. Mix a light wash and block in an oval 5″ high, similar in shape to the one illustrated. While the first wash is still good and wet, start about 1½″ in from the chin and make a rectangular shape about 2″ wide and 2″ long.

Step 2. Mix up your shadow value on your palette. After getting rid of excess moisture with a shake of the brush, start blocking in a dark shadow strip about 1″ wide along the left side of the face. At what will be the eye area, make a slight jog to the right and stop, to indicate the eye socket. Then, with a much thinner stroke, continue to follow the left boundary of the oval around to the neck. Notice that this strip becomes very narrow below the eye and then widens again at the neck.

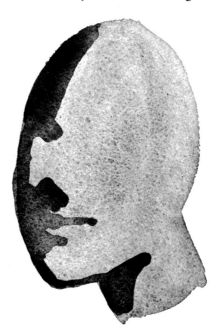

Step 3. While this shadow strip is still wet, draw it out to make the bottom plane of the nose. This is a simple triangle shape, and one corner of the triangle blends with the shadow strip.

Step 4. Now, reload your brush from the shadow puddle, give it a shake, and move on to the mouth. Once again, start at the shadow, which should still be wet, and brush the shadow shapes out into the light area. Indicate the upper lip with a general shadow shape about 1¼″ long. The top plane of the lower lip catches light and creates a shadow under it; so don't really touch the lower lip itself, but make a shadow under it about ¾″ long.

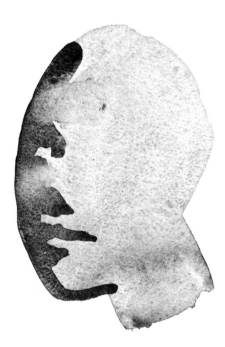

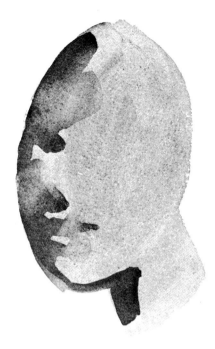

Step 5. Your shadow should still be wet when you do this step. Don't put in any new shadows now, but "connect" the ones you have with your light areas, to make a third, or middle, value. For this general diagram, leave about 1″ at the top of the shadow strip "hard." Rinse your brush, give it a good, hard shake, and place it in the shadow about the eye. Now, soften the forehead by drawing your brush outward and slightly upward about 1″ into the light area.

Step 6. At the mouth, you want to show that the lips curve around the dental arch of the teeth. One way to do this is to lighten and soften the edge of the lips as I've done in my illustration. Rinse your brush, shake it, and draw it right up *through* the mouth in a diagonal stroke. Again, you can blot this area with your tissue. (You'll have to experiment. All this takes practice. The first few times you try, you probably won't get the effect you want, so be patient.)

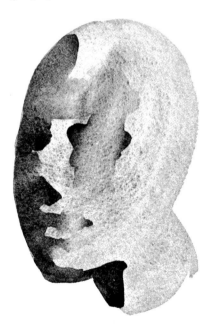

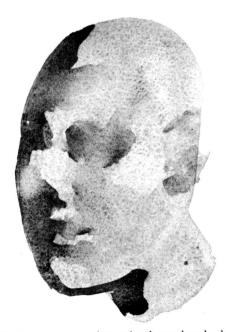

Step 7. Now for the right eye. In the light area, use your shadow value to paint an oval about 1½″ long and 1″ high. Rinse and shake your brush and lighten the middle section of the eye to show the round form of the eyeball and give the eye a feeling of bulk. If necessary, blot this mid-section carefully with a tissue to lighten it. Note that there are hard edges on either side of the eye and soft edges in the middle. Now, continue the middle, light area of the right eye down through the top plane of the cheek.

Step 8. To end your project, reload your brush, shake it out and, starting at the right corner of the mouth, make a very *short* stroke upward toward the cheek. Now, rinse your brush, give it a very good shake, and allow this dark area to flow upward, to show the bottom plane of the cheek. Work this middle value down into the lower cheek, toward the upper lip. Then, indicate the right ear very simply, with an oblong shape.

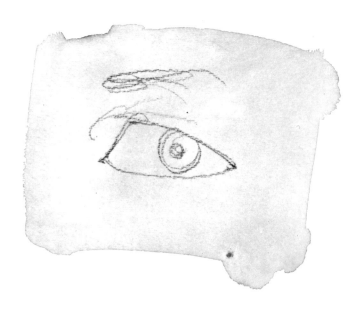

Step 1. Lightly sketch in an eye about 1½″ long and ¾″ high at its highest point, using the shape in my illustration as an example.

Step 2. Mix up a light wash, pass it over the whole area of your drawing, and allow it to dry. Then, mix up your shadow wash.

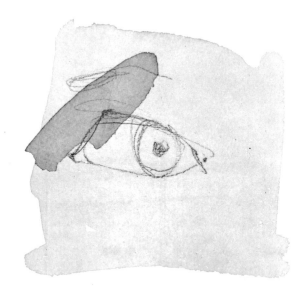

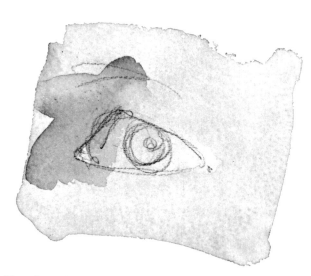

Step 3. Starting about ¼″ above the upper lid, in a line parallel to the left boundary of the iris, make a diagonal shadow stroke downward. Notice that I've painted right over the left boundary of the eye.

Step 4. While your dark strip is still wet, begin to soften the edges. Allow the wash to flow out at the nose bridge to indicate a front plane between the top plane of the nose and the top plane of the forehead. Also, allow some darker wash to flow out into the eyeball and under the lower lid. It's important that you don't worry about the actual boundaries of the eye, but, instead, try to show the big planes of the eyeball and the adjacent nose area.

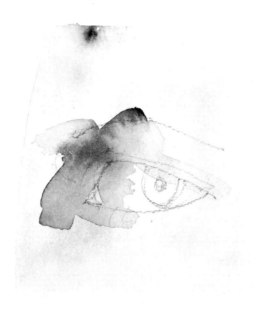

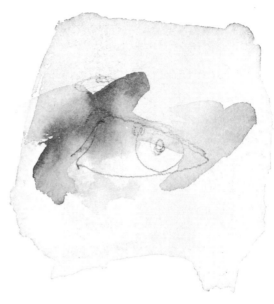

Step 5. Continue to draw your shadow "out." Indicate the shadow on the upper lid simply, with a long stroke that runs the entire length of the upper lid. Blot this stroke lightly just above the iris to lighten this area and to show that the eyeball and upper lid "come out at us" at this point.

Step 6. While the wash is still wet, blot and lighten the lower left, or inside of the eye. After you blot, you might have to draw more shadow out into the light and restate the specific boundary of the corner of the eye. Now comes the important large oval plane on the right side of the eye (your right). Again, make a simple, diagonal dark stroke, beginning above the upper lid and stopping just below the right corner of the eye. Finally, soften the upper boundary of this diagonal stroke with a damp brush and blot it if necessary. You should now have the feeling of the contour of the eyeball.

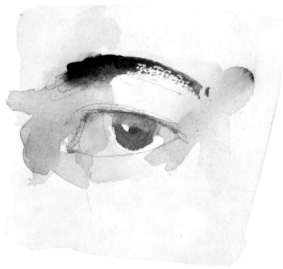

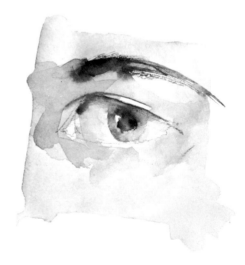

Step 7. Now for the eyebrow. Hopefully, the darker wash is still damp, since you want to put some soft edges on the eyebrow. Use almost pure pigment here, and start at the left, thicker end of the eyebrow, where the edges should be soft. As the eyebrow curves around the side plane of the forehead, your stroke should become lighter and thinner. Here, you might try drybrush to suggest the lightening and thinning, as well as to suggest the texture of the eyebrow. Finally, block in a simple oval for the iris, with the value you used in the upper lid. (In many cases, you might want to use the same value in all three areas—iris, upper lid, and eyebrow.) I've left a small dot untouched in the iris, as a highlight.

Step 8. The iris should still be damp. Using a touch of pure pigment—almost no water—"drop" in the dark pupil, still leaving the highlight untouched. Next, block in a darker strip on the upper lid. As a rule, the upper lid is always darker than the lower lid, since it forms a bottom plane and casts a shadow on the eyeball. I've also made a simple curving line as a general indication of the fold directly above the eye. When you paint a particular eye, however, give special attention to the shape of this fold. Finally, restate some of the darks around the eye. For this final step, allow the previous washes to dry, so you can see exactly what needs more definition and restatement.

Step 1. Sketch in the nose, using the method I just discussed. In my sketch, I've included some of the surrounding features, but don't worry about these surrounding areas—they merely help to give us an idea of the position of the nose on the face. Note that I've sketched in the boundaries of the bottom plane of the nose. This will give you a guide when you block in this area with your darker values.

Step 2. Now, lay a wash over the nose and the surrounding areas. I've left one small dot of white paper, untouched on the front plane of the nose. This will be the highlight. Remember that highlights should always be very small and that one or two highlights on a head are plenty.

Step 3. Now, your shadow shapes. In this case, the bottom plane of the nose and the cast shadow under the nose are the most important dark areas. After mixing up a shadow puddle on your palette, load your brush and give it a good shake. (The first light wash should be dry by now.) First, block in the left eye, which silhouettes the light-struck nose. Watch your pencil guides and make your shadow shape carefully, noting the outer boundaries of the left eyebrow and cheek and, more important, making sure the boundary of the front plane of the nose is right. Stop the stroke just short of the nose tip.

Step 4. Now for the bottom plane of the nose. The entire underside of the nose can be described with a simple, oblong shadow stroke. Then with the same wash, paint the cast shadows under the nose. These cast shadows continue right down and connect with the mouth. (Always tie in as many of your shadow shapes as you can: avoid leaving bits and pieces of shadows spread aimlessly about.) Finally, give the briefest indication of the right eye socket, to make the nose "project" out from the face.

Step 5. I've carried the bottom plane shadow of the nose a bit further, articulating the definite small shapes on either side of the nose tip. Normally, I'd do this when I first put in the bottom plane (Step 4), but here, I want to stress the importance of starting with big, simple shapes before getting involved with small forms. I've always carried the mouth a bit further, just to show how much mileage we can get out of the cast shadow under the nose. You can also use the same shadow wash to describe the mouth and the shadow under the left cheek.

Step 6. Now, the right nostril. Indicate this with a bit of pigment that's almost pure black. (Remember that shadows almost always have some reflected light in them, so never make them black. The nostril, on the other hand, is an accent: almost no reflected light reaches into areas like the nostril.) Notice that the original shadow seems lighter by comparison. Notice also that some of the edges around the nostril are softened where they blend with the adjacent shadows. This makes the nostril seem to be part of its surroundings. Whereas a hard-edged, dark area would appear isolated and unconnected.

Step 7. To complete this exercise, add the very subtle middle values on the light side of the nose. Remember not to make them too dark, or they'll look like shadows, and the nose will "flatten out." (Compare the sketch on the right to the illustration for this step, and you'll see that the middle values in the sketch are just too dark.) Middle values describe the specific construction of the nose areas that are in the light, and they are very important nose necessary in painting a finished head.

Overworked Results. However, there is a danger that if you try to make all the subtle value changes you see, the result will be an overworked and tired area. For example, the middle values are too dark here. The nose has "flattened out," and the result looks overworked.

PAINTING THE MOUTH

Step 1. Sketch in the mouth. We're doing more or less a front view here, and I've tried to draw an "average mouth." (Naturally there is no such thing!) Pay particular attention to shape. Never assume you know the shape of the mouth or of any other feature. Come to the drawing board with a clear mind and an observant eye. Always ask yourself: how does the upper lip compare to the lower lip? Is it thinner or fatter? See how much curvature there is to the upper lip. As a general rule, the upper lip is a much more involved shape than the lower lip.

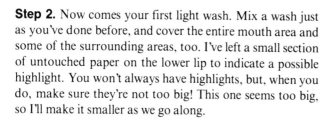

Step 2. Now comes your first light wash. Mix a wash just as you've done before, and cover the entire mouth area and some of the surrounding areas, too. I've left a small section of untouched paper on the lower lip to indicate a possible highlight. You won't always have highlights, but, when you do, make sure they're not too big! This one seems too big, so I'll make it smaller as we go along.

Step 3. Now for your shadow shapes. On your palette, mix up a fairly dark wash—better too dark at this stage than too light. After loading your brush, start at either corner of the mouth. Usually, there is a crease in the skin at the mouth corner, so start your stroke off wider there and then narrow it immediately at the beginning of the lips (this depends, of course, on the shape of the particular mouth you're painting). Make the stroke wider again as you approach the middle of the mouth. As you can see, I've stopped my stroke short of the center of the upper lip and repeated the procedure on the other side, leaving an untouched middle section to indicate roundness around the dental arch.

Step 4. Rinse your brush and give it a good shake. Working quickly (you don't want the shadow wash you did in Step 3 to dry!), connect the two sides of the mouth at the middle, allowing the shadow to flow into the area you left untouched in Step 3. Notice that the middle area is still lighter than the two sides. Notice also that the two sides have become lighter because their washes have been drawn out into the light. Next, draw your shadow down into the lower lip from either corner of the mouth, leaving the middle section untouched.

Step 5. Now, draw the values on either side of the lower lip into the middle area, repeating the process you used for the upper lip. Notice that I've allowed some of the darker areas of the lips to flow out into surrounding skin areas. (Never allow the mouth to appear isolated and unconnected to its surroundings.) One of these soft edges occurs under the lower lip, and is the beginning indication of a bottom plane under the lower lip.

Step 6. Now, the final touches. The main thing to do here is restate areas that need emphasis and darkening. To darken the upper lip, repeat more or less the procedures you used in Steps 3 and 4. On the right side, I've allowed some of the dark upper lip shadow to travel down into the lower lip, to avoid leaving a hard continuous division between the upper and lower lips. Remember to keep the feeling of connection and inter-relationship between areas by using "lost" and "found" edges. The hard division between the lips in the middle area is lost as you soften the edges and you can make the left side even more indistinct than the right side. If you make an area too vague, always wait for it to dry, or almost dry, and then add a final touch of darker value to the edge.

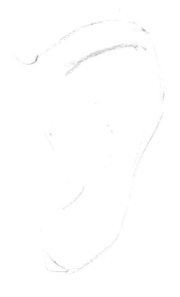

Step 1. Look first at the outer shape of the ear. Notice that the top is a simple curve that becomes straighter as it starts down at the back. Some ears can be described by a simple curve along the back edges, others by almost straight lines, and still others by a much more complicated system of curves and angles (like the one we're drawing here). Sketch in the inner shapes very lightly. You want only a light "blueprint" as a guide when you block in the inner shadow shapes.

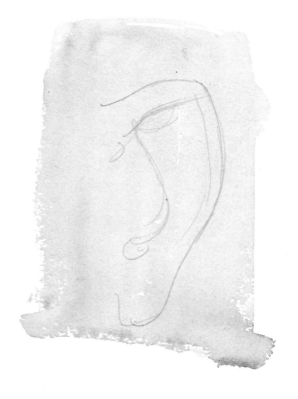

Step 2. Lay a light wash over your drawing and allow it to dry.

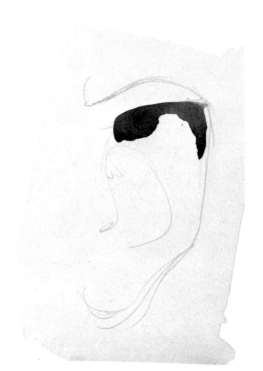

Step 3. Begin blocking in the inner shadow shape under the fold that runs along the top of the ear. There is usually more distance between the top fold and the inside of the ear near the skull, so start with a fat shadow shape on the left, and narrow it as your stroke reaches this large inner space. (This large inner form doesn't always go directly up to the top of the ear flap as I've indicated here, but there is always some form which makes up the inner ear area.) Back to your shadow shape. Notice that it widens, then gradually narrows again as it starts down the right side of the ear.

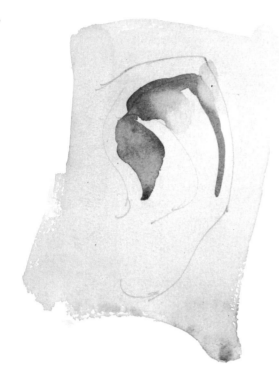

Step 4. Now for some edge-softening. Rinse out your brush, give it a good shake, and soften the lower, inside edge of the large shadow shape before it narrows. The soft edge describes the crevice in the inner ear form. I've also softened the outer edge of the shadow strip on the right, after painting this strip almost three-fourths of the way down the ear. Now back to the front of the ear. With your shadow wash, indicate a very narrow spot on the left, under the original shadow shape, then the very large indentation that is typical of almost all ears. In this case, I've shown the indentation as a "teardrop" shape.

Step 5. More softening takes place as you use your damp brush to lighten and soften the inner edge of the dark teardrop shape. Darken the area above the ear to indicate hair and to create some background that will offset the lighter sections of the ear. It doesn't matter if the softened area on the right side of the ear is still wet and you get a soft, "lost," edge between this shadow section and the background. See how the hard and soft edges, both within the ear and around the outside, help to show the particular construction of the right side of the ear.

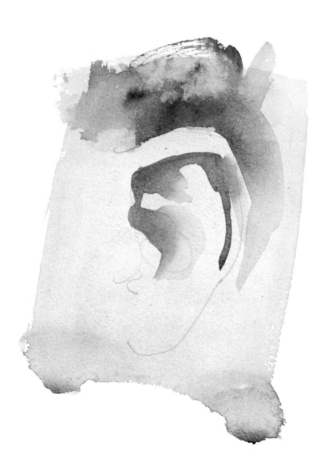

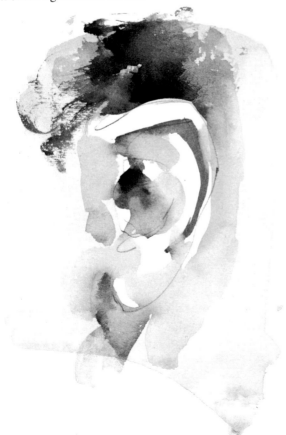

Step 6. Below the lobe, which is quite light, add the surrounding dark tones. Don't work into light or fairly light areas, and don't add too much detail, or you'll destroy the feeling of your light area. After you've established your surrounding darks, let some of the darker values flow out in the light bottom lobe as subtle middle values. Blot these middle values so they don't become too dark or too large. Now use your darkest dark to indicate the center section of the ear, using wet-in-wet to keep the edges soft. Finally, add some drybrush for hair, and a middle value along the head, to contrast with the light "flap" below and along the front edge of the ear.

Step. 1. Concentrate on good outside shapes as you sketch in the boundaries of the top part of the head. Draw lightly, and be ready to restate a shape without erasing if you can make it more descriptive of the hair and head. Mix up a middle wash—not as light as your usual first value—and start washing in the hair and the left side of the face. Naturally, some light areas must be left untouched, but as a general rule, remember not to separate shadow areas according to lighter and darker values in the beginning. While this wash is still wet, draw it out into the right, or light, side of the hair and face. Notice that I've left some areas of the hair untouched.

Step 2. Before this wash dries, scratch out some light strands with your fingernail. (In my illustration, notice that the darker, hard edge I mentioned has softened. This was un-intentional, and I'll have to restate this area when the wash dries.) Don't do anything more until the whole area is dry. (If you were doing a portrait, you would now go on to work on the rest of the face and come back to the hair later.) The only thing you might do now is blot some areas that have become too dark, but remember that all of your washes will dry lighter, so don't blot too much. When everything is dry, put in your darker darks.

Step 3. Now, working quickly, allow the shadow on the side plane to merge into the hair. Nothing is precious here; if you lose the light section of the hair on the shadow side, don't worry. You can always lift it out with a tissue. Reload your brush and, working toward the right, add more darks. Leave as much white paper as possible, but, again, don't worry if you cover some of it up with your strokes. Use more and more drybrush as you work here. Blot some of the darker areas on the right: don't let this section become darker than the shadow side.

Step 4. Now, the final—and really the most difficult—step. The difficulty arises with that desire to "over-finish." What you need is some judicious drybrush work! You don't want the drybrush to be black, but it should be nice and dark. Leave the light areas almost untouched, with just the barest amount of drybrush work. Don't go into your shadows except to restate the darks where necessary. For this re-statement, use overwash and, when this is dry, add one or two strokes of drybrush. Now add some background tone to offset the lighter hair values. While the background is still wet, scratch into it to suggest the short hair strands.

Step 1. There are several approaches to take, once you've sketched in your subject. You could wash in just the face and wait for it to dry; or you could wash in the whole head and the hair area and wait for both to dry before going any further. It doesn't matter which approach you choose: the results will be the same. In this case, I've laid a fairly light wash over both the hair and face and allowed it to dry.

Step 2. Since the hair is black, start right off with black paint. Have just enough water in your mixture to make the paint move. This dark wash should not be drybrush, and there should be no build-up of pigment. The wash should be dark, but always transparent—not opaque. It's important that you try to arrive at the right value as early as possible.

Step 3. Continue to wash in your darks as you work down the left side. Feather the ends of the hair mass. (My first wash wasn't absolutely dry in the neck area, so some softening took place on the left when I painted in the hair. This was accidental, but it works well!) On the right, wash in the same dark wash, but blot it with a tissue to lighten the area, because it is effected by light.

Step 4. Now, restate your darks. If you started with a good, rich, dark wash this will be just an emphasis of your darkest accents. Finally, scratch out a few light strands. Use a little background dark to make lighter strands stand out. Around the outside of the head, you can use drybrush to suggest softness. Notice that I haven't outlined the face with my darkest darks. This allows the face to "breathe." Hard boundaries all the way around the face would have isolated it.

PAINTING THE HAND

Step 1. Begin with a single line to describe the arm, the wrist, and the outer boundary of the first finger. Retrace and extend this line to indicate the second finger. Then continue the same line around the tips of the second and third fingers, showing only the indentation between these two fingers. Now, go back to the first finger and continue your line around the tip and along the inside boundary until it meets the boundary of the second finger. Make a small dot to indicate the outside boundary of the fourth finger. Then go back and extend the lower boundary of the lower wrist up to meet this dot and continue the line around to complete the fourth finger. Finally, sketch a simple oval to indicate the back of the hand, and draw another light oval along the line where the knuckles will be.

Step 2. Wash in your sketch of the hand with your light wash. Notice that I've tried to improve the shape a bit with this wash. The drawing we just did is very general, lacking the particular small shapes that are normally important in drawing the hand. But I don't want you to worry too much about these small shapes, since this exercise is really just a beginning stage in learning to paint hands.

Step 3. In this case, the wrist is bent downward and the light is coming from the right side: the area below the wrist is bent away from the light and is actually in shadow. Mix up a dark gray on your palette, load your brush with the dark wash, and give it a good shake. Then block in a simple rectangular shape on the lower wrist area. Notice that the boundary of your shadow next to the hand should have an outward-curving, not angular, shape.

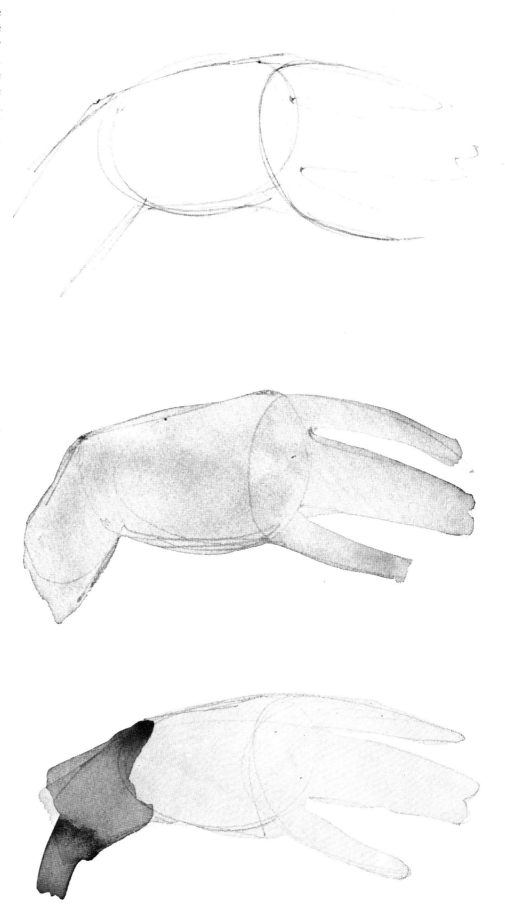

Step 4. While this wash is still wet, go on to the back of the hand, which is turned only slightly away from the light. Use a middle value here. Starting along the curving line you drew earlier to show the knuckles at the top of the hand, wash in a value that's lighter than your shadow wash—but not too much lighter! You want definite, obvious planes on this basic hand. It would be better for this wash to be too dark than too light. I've made a rather wavy boundary along the knuckle line to suggest the bones in the knuckles.

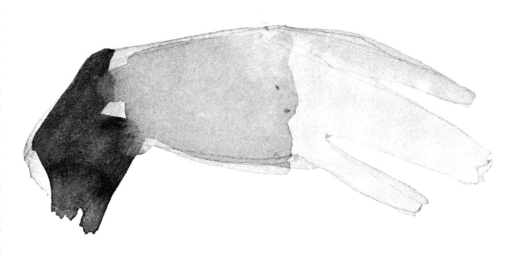

Step 5. The back of the hand is a wedge-like form, and the fingers are attached to the wider end. Since the light is coming from the right, this wider area, where the fingers meet the main part of the hand, is the lightest area. Don't touch this section with your middle wash; instead, go on to the fingers. The fingers are almost parallel to the back of the hand, so they don't catch much light. Starting with the first finger, block in a middle wash between the first, lower joint and the base of the knuckle on each finger. Then draw some of the wash toward the back of the hand, almost connecting it to the shadow shape there.

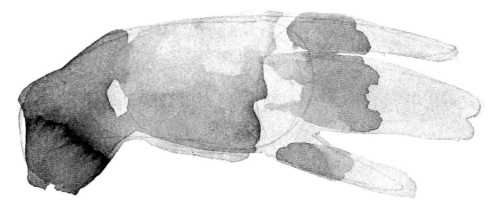

Step 6. Now you have a very basic hand that has form and mass. Add a few thin shadow indications at the bottom planes of the fingers and at the tips of the second and third fingers. Make these shadow indications very casual, leaving them broken here and there and varying their thickness. Finally, make a simple thumb silhouette, first with your light wash and then with some shadow wash. This isn't really necessary, but it helps make the hand look a bit better.

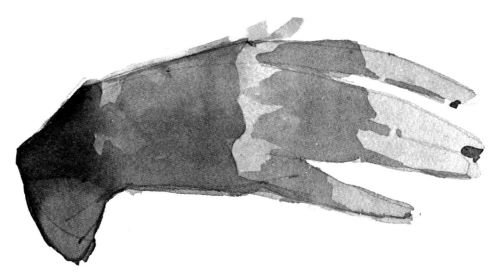

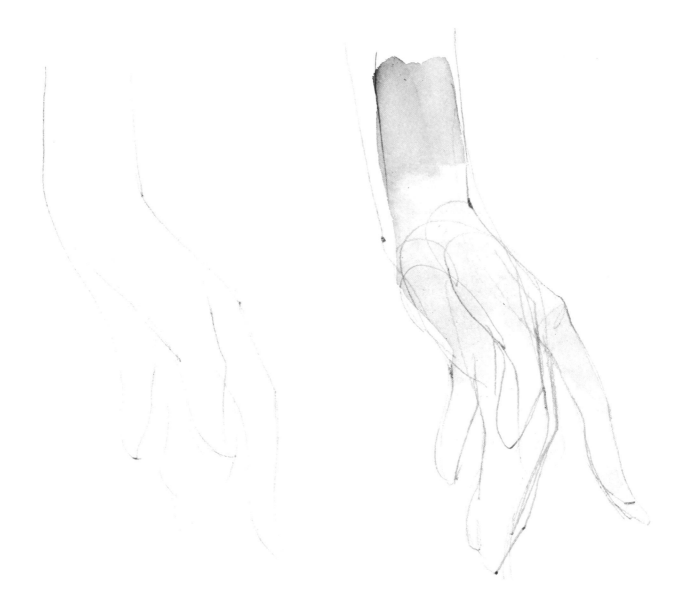

Step 1. Draw the hand, using the same method outlined in the previous demonstration. I've left this step incomplete to show you that the wrist lines extend to form the outer boundaries of the first and fourth fingers. Begin with a flowing line that will give you a foundation for the specific forms you'll develop later. *Don't* start out with the specific shapes.

Step 2. Now complete the drawing. I've developed more definite shapes, but the flowing lines are still very important. In your usual light value, wash in the hand and try to develop some of the important small forms of this particular hand. Notice that I haven't stayed religiously within my boundary lines. Notice too how formless the hand looks at this stage, without shadow shapes.

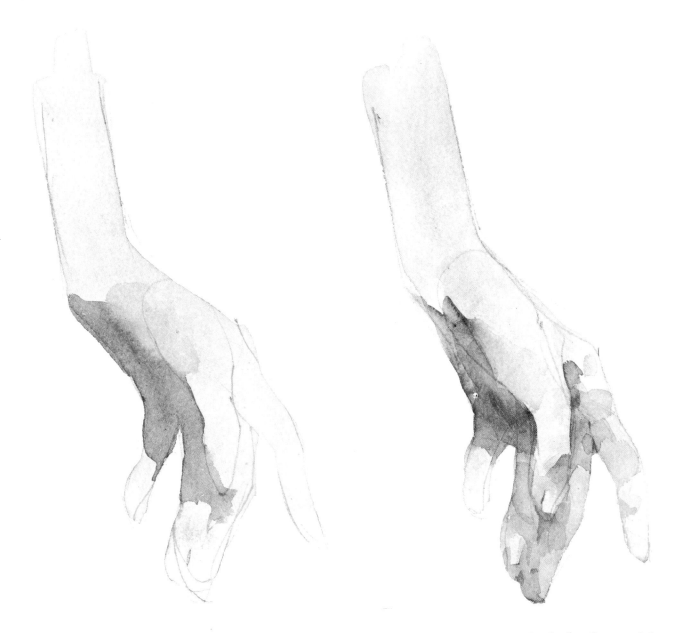

Step 3. Mix up your dark wash, and simply block in the shadow on the underside of the hand. Try to get as much mileage as you can out of this shadow shape. Let it go into areas which are not quite in shadow but are still darker than middle lights. In other words, generalize as much as you can with the many areas in the vicinity of the shadow that are close to the shadow in value. Before your wash dries, soften some areas where the boundary between light and shadow is subtle, at the forward edge of the shadow. Notice how this soft edge describes the "flesh" areas in the thumb, leaving the more "bony" areas to be described by a harder edge.

Step 4. Now for the shadow under the first finger and the fleshy area at the base of that finger. A very hard edge separates the top plane of the thumb from the underside of the first finger area. The first joint of the thumb is bent, so the top knuckle is in shadow. Once again, generalize with your shadow shape, allowing some shadow to flow onto the top knuckle of the thumb. This value difference between the two sections of the thumb shows that the thumb is bent—an obvious statement, but a good example of how planes of light and shade can show the relative positions of forms. Leave a small light area at the end of the thumb to indicate that part of the fingernail is in light. Don't try to be too accurate here. Now, you can add more detail with small shadow shapes, but remember—keep it simple!

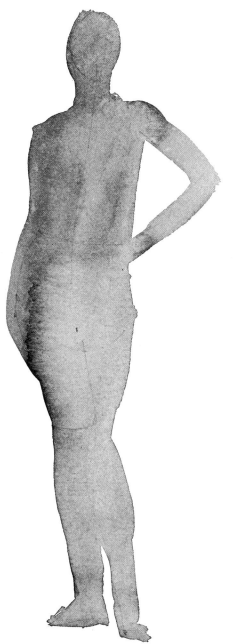

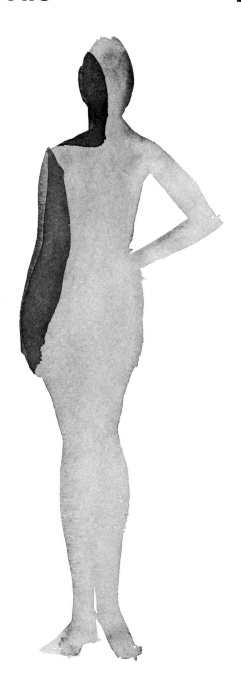

Step 1. Block in the figure illustrated here. This figure will be described with large, simple masses, and the arms and legs will be indicated by single strokes whose width is dictated by the amount of pressure put on the brush. To make long, flowing masses, control the width of the stroke to conform with the contours of the figure. The actual narrowing and widening of the stroke isn't difficult, but controlling the hand, to make the width of the stroke change at just the right place, isn't so easy. It will take a good deal of practice.

Step 2. Mix up a darker value. Don't worry too much about the value of this shadow; just make sure it's obviously darker than the value used in Step 1. Block in a strip running down the left side of the silhouette's head. This strip should cover about half the face. As the strip reaches the base of the neck, take a short, tapering jog over toward the left shoulder. This stroke tapers and gets lost because of the construction of the shoulder. Start a new stroke at the point of the shoulder. This shadow form will eventually describe the whole side of the torso, including the arm.

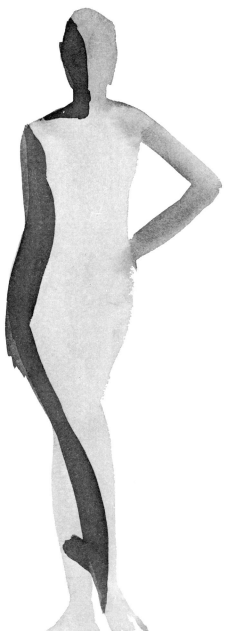

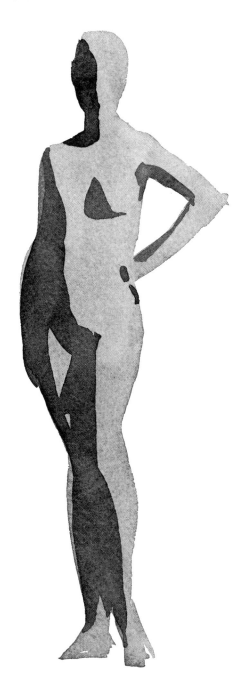

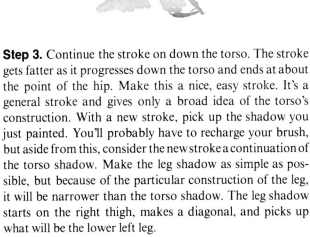

Step 3. Continue the stroke on down the torso. The stroke gets fatter as it progresses down the torso and ends at about the point of the hip. Make this a nice, easy stroke. It's a general stroke and gives only a broad idea of the torso's construction. With a new stroke, pick up the shadow you just painted. You'll probably have to recharge your brush, but aside from this, consider the new stroke a continuation of the torso shadow. Make the leg shadow as simple as possible, but because of the particular construction of the leg, it will be narrower than the torso shadow. The leg shadow starts on the right thigh, makes a diagonal, and picks up what will be the lower left leg.

Step 4. Now start blocking in the lower right leg. Finish the shadow describing the lower legs; then make an upward stroke to the crotch. Describe the underplane of the stomach. The leg and lower torso shadows are now connected with the upper torso shadow. All the major shadows should form a cohesive pattern. Avoid pieces of shadows that give the figure a disjointed look. The shadow describing the left breast and the left arm can't be connected with the main shadows, so, rather than stretching the point, block in both shadows by themselves. The breast shadow is a simple, triangular shape, while the upper arm shadow is a thin, straight stroke which continues along the top of the lower arm. Add a small stroke to show where the hand is resting on the hip.

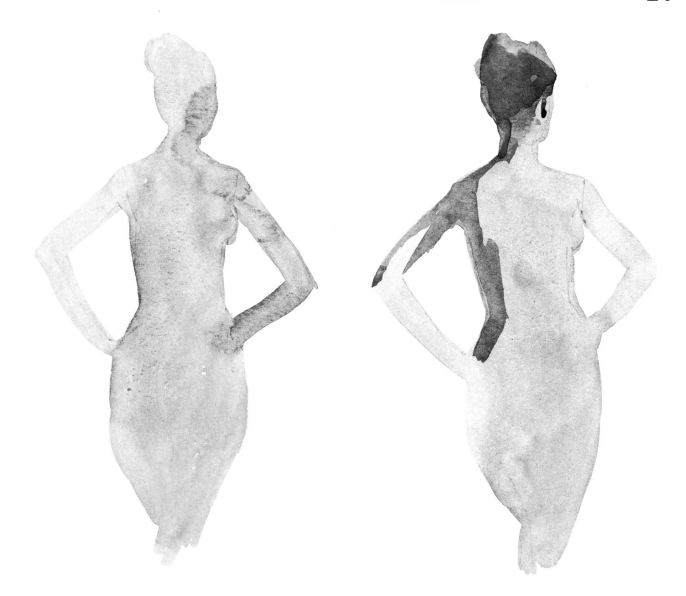

Step 1. Make a simple silhouette and allow it to dry. It's perfectly okay and good practice to work directly with your brush without pencil guides. On the other hand, pencil work is all right, but don't make hard, precise outlines, and simply fill them in. Sketch just the torso and upper legs to stress the involved construction of the back.

Step 2. Mix up a shadow value. Start with the hair; then narrow the stroke to describe the neck. The stroke changes direction at the base of the neck. As the stroke follows the line of the shoulder, it slowly gets fatter until it reaches the side plane of the shoulder blade. Block in this plane and the shadow of the left arm and its cast shadow. Continue the stroke to the bottom of the shoulder blade, where the wash goes further out to show the rounded form of the ribcage.

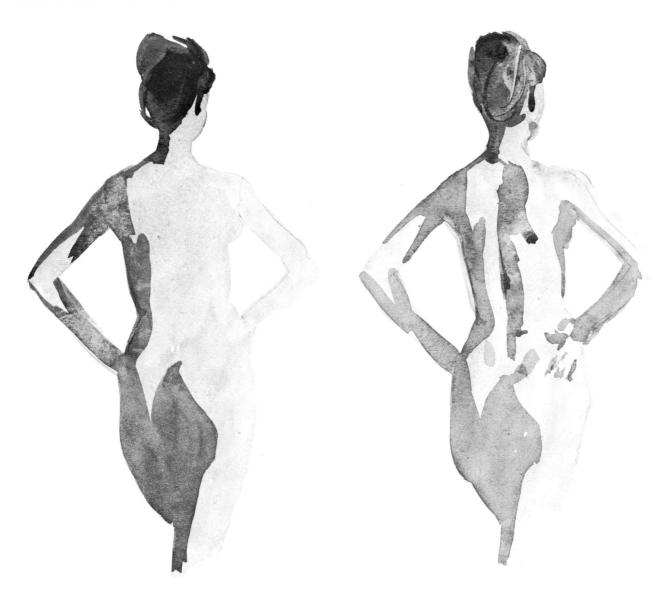

Step 3. The wash now reaches the side plane of the lower torso. The inside shape here is quite straight, contrasting with the curving forms indicating the lower back. Block in the whole shadow plane with a single shadow. A big shadow shape like this is very descriptive. One value does what it would take many small, subtle value changes to accomplish. The use of one value works as long as the shadows are right in size and shape! This shadow shape makes a subtle curve over the backside and takes a straight jog down the leg.

Step 4. Make the side plane of the right shoulder blade quite thick, as opposed to the much thinner plane running down the backbone. The brushstroke should emphasize the straightness of these planes and their slightly angular quality. You're showing the boney, much sharper form of the back in contrast to the more rounded forms of the lower torso. The shadow cast by the upper arm follows the rounded form of the ribcage and disappears as it approaches the hip. Make a large, simple shadow on the lower arm. This big shadow shape shows that the arm is pulled back, causing the lower arm to be away from the direct path of light. If this arm had been in the light, you would have known that the elbow was pulled forward.

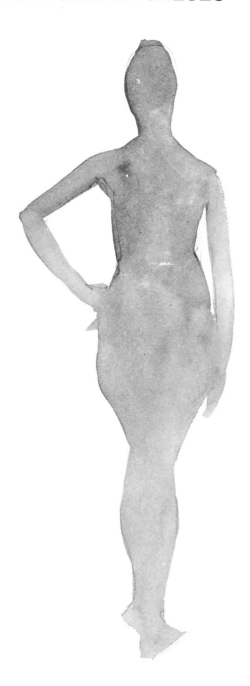 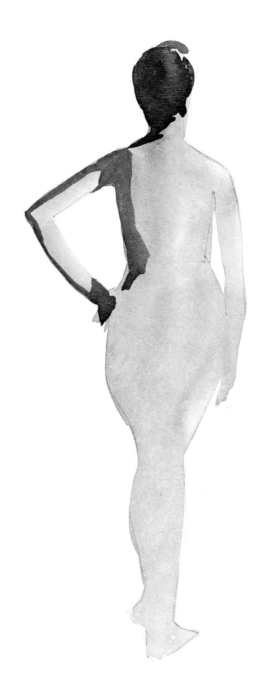

Step 1. Make a simple silhouette. Allow this first wash to dry. Then, with a considerably darker value, block in the shadow shapes, beginning with the hair. Remember that the amount of bleed (or blend) you'll get in the next step depends on how wet a brush you use and how wet the shadow is. Don't paint all the shadows. If you paint in all the shadow shapes right down to the feet now, the shadows in the shoulder and upper back might become too dry for blending.

Step 2. After doing only about half of the shadows, go back and do the blends. Rinse your brush and give it a good shake. Soften the neck shadow first by running the damp brush along the shadow boundary, allowing some shadow value to bleed out into the upper middle of the back. Don't over-work this; make just one or two passes with your brush. If the bleed is going out too far, blot the brush lightly with a tissue after each stroke. Since your damp brush acts like a sponge, you can control the amount of bleed using only the brush. If you blot the brush with a tissue after each stroke, the brush stays damp, rather than becoming actually wet. Soften the shadows in the middle of the back. The shoulder blade is often a sharp, boney form, so leave it untouched. The back is less definite, so make a softer edge here. Finally, begin to fill in the shadows of the lower torso.

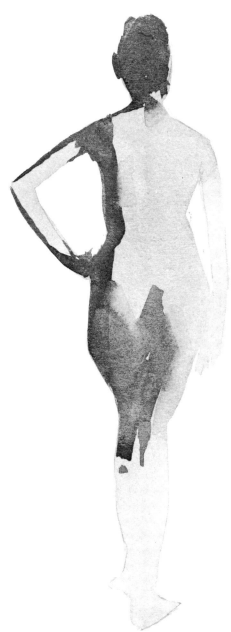

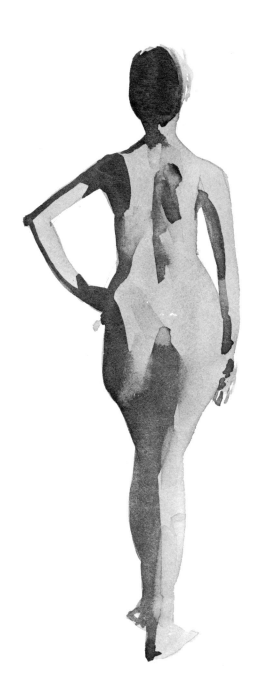

Step 3. Soften the shadows on the rounded forms of the buttocks to contrast with the harder edge in the upper section of the lower torso. Sometimes, hard edges, like the one on the hip near the hand, are left purely for the sake of making them a different shape from the adjoining soft edge, and vice versa. When all edges are soft, the figure looks mushy and formless; when all edges are hard, the figure looks like a cutout. You want a combination of hard, precise edges and soft, sometimes "lost" edges. Now add the rest of the leg shadows along with some shadows to describe the middle of the back. Blend the leg shadows. Notice that by the time this was all done, the leg shadows were almost dry and didn't blend too well.

Step 4. Block in the right arm. This time, don't blend any edges, but blot the lower arm shadow to lighten it and give the appearance of a soft edge. Shadows can be blotted to lighten those that have become too dark or just for the sake of a subtle value change within the shadow. Here, blotting gives a suggestion of softness.

Step 1. The first steps in this project will be just the same as in the previous lesson. Wash in the silhouette over carefully drawn boundaries. Use Payne's gray or ivory black.

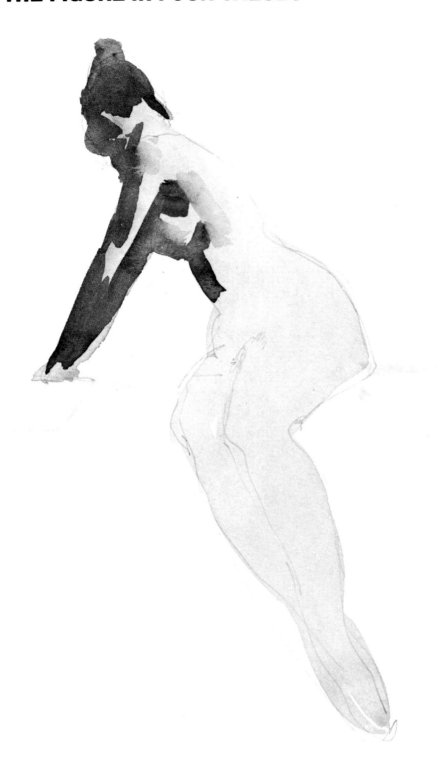

Step 2. Now come the shadows. Starting with the hair, black in the darks carefully. The ear is light-struck, so paint around it. Work around the chin line and on to the upper arm, shoulder, and arms. To show the soft underplane of the shoulder, allow some of the shadow to flow out into the light by using a clean, damp brush to make a blend. Leave the rest of the edges in the arm hard to show the difference between the harder forms and the much softer feeling in the shoulder muscle. It's not very important to articulate the fairly complicated forms in the upper torso. Here again, the differences in edges suggest the qualities of the forms. Contrast the rounded front of the breast with the much harder form on the underside of the breast.

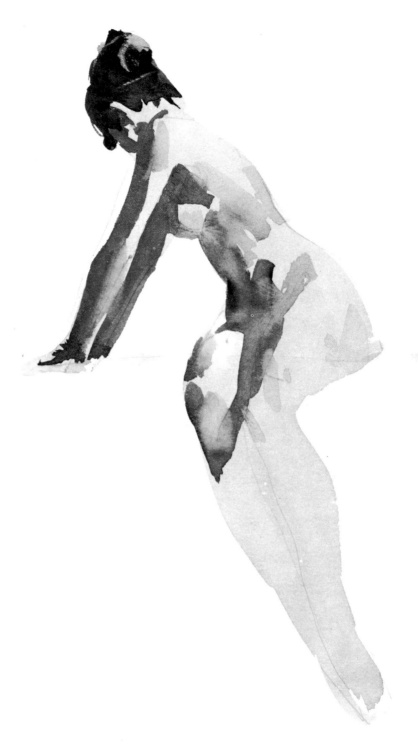

Step 3. Go back and block in the hair with deeper color. This will be one of the darkest parts of the figure and noticeably darker than the skin tones in shadow. The dark accent of the hair gives the shadows luminosity. Continue with the work on the torso. To indicate the form of the ribcage, add a light middle value. These middle lights separate the lighter areas of the shoulder and hip. This is a good example of value changes explaining the construction of the body. The upper back forms a top plane; then the plane changes as it passes down the back and becomes an underplane. Since the hip protrudes, keep your values light once again to show this protruding top plane. Carefully indicate the large front plane of the stomach and continue the shadow wash down the legs. Note the shadow separating the upper legs. The left side of the shadow is straight and hard. As a rule, cast shadows are hard-edged.

Step 4. Soften the shadow on the right knee. The round form contrasts with the harder cast shadow on the upper right leg. This is another example of edges showing the character of each form. Finish up the lower legs with a large, single wash to generalize the shadows into simple masses. Now add a few more dark accents to give the figure its full value range. Add no more than three or four accents to separate the left arm from the right arm. This right arm is behind the breast. To show this, add a dash of very dark value where the right arm stops and the breast begins. Don't paint the whole right arm with this darker value. Add another dark to the right wrist area. This indicates the lack of any reflected light between these two wrists, which are held tightly together.

In contrast, the mid-section of the arm looks lighter and has the feeling of reflected light and luminosity. There's no reflected light under the breast, so add another darker accent. To separate the shadows describing the lower legs from the adjoining cast shadow on the couch while preserving a feeling of "lost edges," add just one small dark accent. In the same vein, separate the knees by adding another dark where the left knee hits the underside of the right upper leg. At first add these darker accents when the shadows are dry. When you become more adept, you'll add these darker accents wet-in-wet, since all edges in shadows should be soft.

The colors you'll use for figure and portrait painting will depend on three considerations. First, you'll use colors that mix well for flesh tones. Next, you'll use colors that fit the particular complexion you must paint. And finally, you'll use colors that appeal to your individual color sense. There's no single formula for flesh tones. The combinations I suggest should be considered just that: suggestions. However, it will be easier for you to follow the color demonstrations if you use the same colors I'll be talking about to mix your washes.

Cadmium red light. My "basic" red. It's really the only red I use to mix flesh tones.

Alizarin crimson. This color has great tinting power and tends to dominate a mixture if the other colors aren't also very strong. Alizarin is a must for mixing rich darks in darker complexions, clothing, hair, and backgrounds.

Cadmium orange. I don't use this color very often, but a touch of orange can pep up a light area, and it can sometimes breathe life into a light flesh tone.

Cadmium yellow lemon or cadmium yellow pale. Both excellent yellows. They're the only cadmium yellows you really need.

Hooker's green. The most useful green. You *can* mix your own green, but I prefer having it ready-mixed.

Sap green. Again, you can get by easily without this color, but I use it quite often.

Cerulean blue. I like this color's subtle, delicate mixing qualities. I use it in all my complexions.

Phthalo (phthalocyanine) **blue.** You need this for mixing rich dark colors. I use it often with alizarin crimson; these two strong colors are a perfect match.

Yellow ochre. I use this color a great deal to mix flesh tones, and I interchange it with my light cadmium yellows. This and the siennas listed below are the *earth colors*. These colors are necessary to any watercolor palette.

Raw sienna. This is a darker version of yellow ochre. It's very useful in the shadow areas of flesh tones.

Burnt sienna. I don't use this color in flesh tones, but I do use it a great deal in other areas. It mixes well and can make some fine darks and handsome grays.

Burnt umber. This color is a must: it's the darkest earth color. I use it in my darkest areas when I paint a head.

Black. I don't use black very often, but I always have it handy. Black doesn't mix well with other colors and, unless you know what you're doing, I'd suggest you use burnt umber as your basic dark.

Now that I've suggested a palette of colors, I'll discuss the various mixtures of those colors I'll be using for the following full color portrait and figure paintings. I'll discuss mixing only flesh tones here, because I think that's the area that troubles students most.

Naturally, there's no single way to paint flesh tones: complexions differ from one subject to another. But it's certainly possible to generalize to some extent, so I'll outline some general combinations you can use to paint light and dark complexions. I don't say these are the only mixtures to use—the colors *you* use will be your mark as an artist—but start by using these colors and then experiment with your own mixtures.

I generally use these basic colors for mixing flesh tones: cadmium yellow pale, cadmium yellow light, cadmium yellow lemon, yellow ochre, raw sienna, Hooker's green, sap green, Phthalo blue, and cerulean blue. For the lightest complexions, I use cadmium red light mixed with cadmium yellow pale or cadmium yellow light. I occasionally mix yellow ochre with my cadmium red light for light complexions. Whether you use a cadmium yellow or yellow ochre depends on your own feeling about the complexion. I think the cadmium yellow creates a fresher complexion tone, but yellow ochre is easier to handle.

Just remember that a little bit of any yellow goes a long way when you're mixing it with red: start with a very small amount of yellow, and see what happens. Remember also that the combination on your palette will look different when it's applied to white paper, so be sure to test each new mixture. The first result probably won't be satisfactory and you'll have to continue mixing. It's impossible for me to give you any more specific instructions on mixing: I can't tell you exactly how much red you should mix with exactly how much yellow. Mixing takes a great deal of experience, so just experiment with various ratios of red to yellow. (When you finish adding one color, be sure to rinse your brush before you add another color.)

Now let's try some of the various combinations you can mix for light and dark complexions.

Cadmium Yellow Lemon and Cadmium Red Light. Here, I mix cadmium yellow lemon with cadmium red light. Notice that I place these colors about an inch apart. Then I go back to the water supply, rinse my brush, and, with a damp brush, come back and draw the two colors together to create a fairly light complexion tone. Actually, I've used a bit too much water in this particular swatch and the result is a little too light.

Yellow Ochre and Cadmium Red Light. In this case, I substitute yellow ochre for the cadmium yellow. The result is very similar to the first swatch, and I'm sure it's impossible to tell the difference between the two blended areas. It's quite safe to say that you can use cadmium yellow or yellow ochre interchangeably.

Yellow Ochre, Cadmium Red Light, and Cerulean Blue. Now I add a third color—cerulean blue—to my combination. It's usually necessary to cut the intensity of the yellow-red combination and, as you'll see in the following demonstrations, many areas of the face are very cool. Notice what happens here when the blue is mixed with the yellow-red combination. We can see the warm color slowly changing and becoming much cooler.

Raw Sienna, Cadmium Red Light, and Phthalo Blue. Now we're getting into dark complexions. Here, I use phthalo blue instead of cerulean blue, raw sienna instead of cadmium yellow, and less water to mix these colors together. The result is much darker than the previous swatches.

Step 1. I mix my initial wash with three colors: cadmium red light, cadmium yellow pale (you could use yellow ochre), and a touch of cerulean blue (or sap green). The result of adding this third, cool color to the wash will be a rather subtle transition between the warm and cool areas on the face. I block in the left side of the nose, the left cheek, and both eye areas.

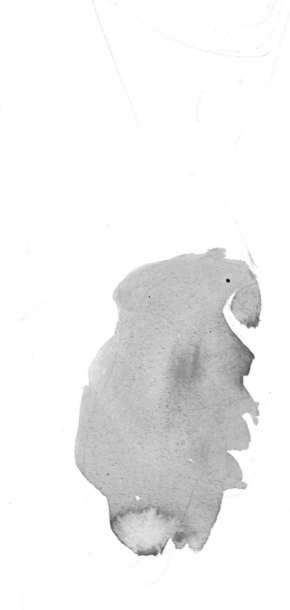

Step 2. I extend my first wash to cover the left side of the face and neck, paying attention to the contours of the nose, the upper and lower lips, the chin, and the neck. (Notice that a "balloon" has developed in the neck and that an area of the left cheek is too dark. I'll ignore these bothersome mistakes for now. They'll probably be hardly noticeable on the finished head.) Now I mix a puddle of cerulean blue on my palette, load my brush and shake it, and start washing in shadows wet-in-wet. I work upward from the warm wash, drawing the cooler color to the left temple, across the forehead, and around to the right eye socket. I leave a small finger of light jutting into this shadow, as the beginning of a light rim on the top plane of the nose.

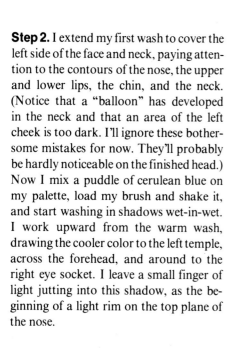

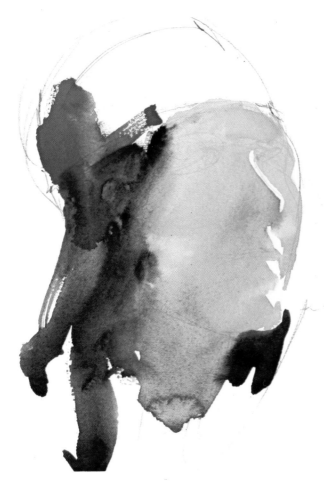

Step 3. Without pausing, I work the cool wash down into the lower cheeks, the mouth area, the chin, and the neck. Then I mix some cool color into my basic warm wash and block in the shadow on the right side of the face. This area is not as close to us as the left side of the face, so it should be cooler than the closer areas. When the washes on the face are just damp, I start blocking in the hair, using burnt umber and burnt sienna mixed with cerulean blue. Then I use undiluted cadmium red to begin blocking in the headband. (Notice that, even with pure pigment, some of the red has bled into the hair. I'll fix it later.)

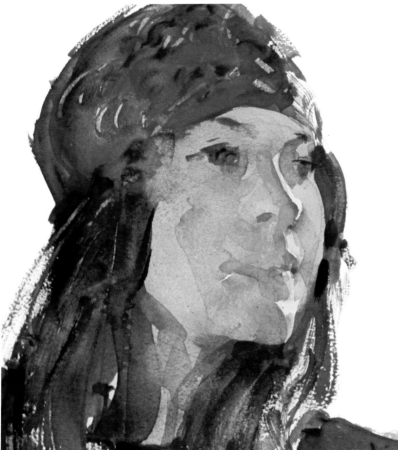

Step 4. I complete the headband, hair, and shirt, occasionally blotting those areas with a tissue to lighten them, to suggest texture, and to soften edges. Now I try to suggest the eyes while I keep them soft and indistinct. I begin with light brown washes and slowly work toward the area where I'll place my darkest dark. For this very dark accent, I use pure burnt umber with a touch of cerulean blue, and I make only a very small dot. I darken the complexion by restating the dark rim along the nose and suggesting shadow on the front plane of the face. Then I add a dark accent at the light corner of the mouth. While the headband is still wet, I scratch out some highlights. When the washes on the face are dry, I darken them to make the planes more definite.

Step 1. I wash in the light values, covering the whole face. I want a fresh complexion, so I mix quite a bit of cadmium yellow lemon with my cadmium red. Although I don't often use cadmium orange, I do try it occasionally in a light, fresh complexion such as this, and I'll add a bit of it here. The main light is coming from the right, so I lighten the area around the left eye by blotting it lightly with my tissue. Although I'm putting wet washes next to one another, I'm not too worried about the bleeding that will take place.

Step 2. When my first washes are dry, I start adding some browns to the front section of the hair, using burnt umber. Then I mix up a warm shadow wash of cadmium red light and yellow ochre. (You could use raw sienna instead of the ochre.) I want this wash to be quite dark, so I use very little water. I start blocking in the shadows, and I indicate the cooler, reflected light by adding cerulean blue wet-in-wet to make a good blend.

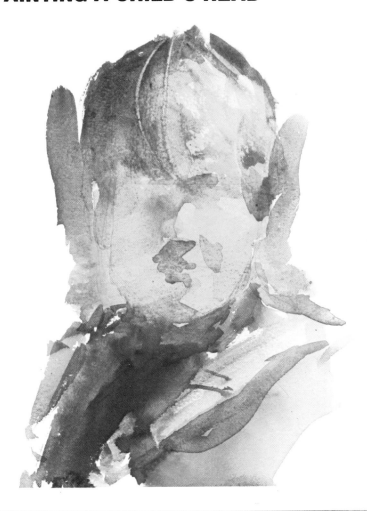

Step 3. As I work, I hold off on adding the background areas adjacent to the light sections of the face until those sections are dry. I want crisp edges on the boundaries that face the light, but the boundaries in the shadow areas should blend and blur. My boundaries on the left side aren't correct, so I wipe them out with a tissue. As areas in the light become dry, I restate edges and forms. These are definite shadows on the left side of the face, so I add a darker wash. I think you can see how fluid my painting is at this stage. This is really why I don't do a more careful preliminary drawing! I like to feel that I'm not bound by exact outlines. This is my way of working, however, and you might well prefer to work with more careful guidelines.

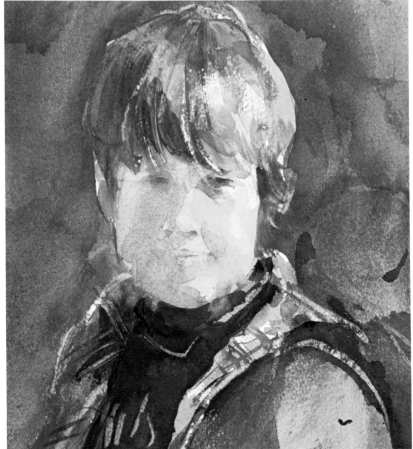

Step 4. I'm concerned here that the head is not resolved. The shadows really need to be darker and more definite—but I've destroyed so many pictures by adding another shadow wash! I might gain more definition if I add one here but I also might lose the freshness that's so important. Although some watercolor paintings can be corrected and reworked without being damaged—in fact, corrections and reworkings might occasionally be assets—some paintings demand that "premier coup" look that you can only get with just one or two fresh transparent washes. In this sketch, I've managed to leave the head alone, but I've overworked the jacket. Can you see that the jacket looks "tired" in comparison to the face?

Step 1. I mix up a rich wash of cadmium red light, raw sienna, a very little bit of cerulean blue, and sap green (I could have used Hooker's green). I want only a very small amount of cool color in this first wash, since I want it to have an overall feeling of warmth. You can see that red is the dominant color. As I work out toward the boundaries, I add more cerulean blue on the right side of the head, and more sap green on the left. (Again, I could have used Hooker's green.) I work quickly, wet-in-wet, using more pigment as I add cool colors to my puddle. The light is coming from the upper left, so, before my first wash dries, I blot the upper left side of the face lightly with a tissue.

Step 2. I mass in the hair, using almost pure burnt sienna and Payne's gray with a little phthalo blue. The face has already dried, and a hard edge is developing as I add the hair. This is fine on the left side, but I want a soft edge in the shadow; so I clean and shake my brush and work it up into the hair to soften and lift out the hard edge. I use almost the same mixture on my shadow shapes, but I substitute Hooker's green for sap green to make an even darker wash. Working down the middle of the head, I wash in my shadows broadly, developing the shapes of the eyes, nose, mouth, and chin. Now I add more cool color—primarily cerulean blue—to my puddle and wash in the right side of the face. Reflected light makes this area a bit lighter than the center of the face, but not as light as the main light areas. While my shadow wash is still very wet, I run a clean, damp brush down the right side plane to soften the division between the shadow and the areas of reflected light.

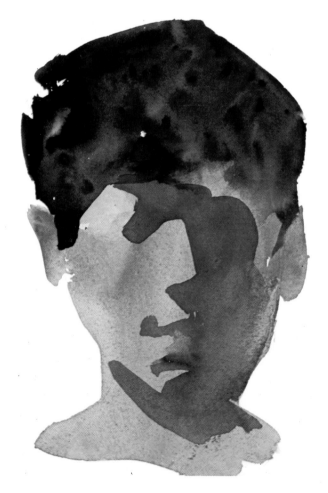

PAINTING A YOUNG BOY'S HEAD

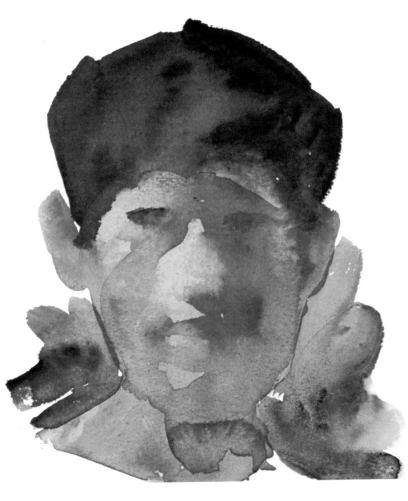

Step 3. Starting at the left eye, I soften the edge of the shadow across the eye form, leaving the hard edge at the nose bridge. Then, I draw the wash down into the cheek and continue all the way down to the chin to show the front plane of the cheek and to describe the high cheekbones. Quickly, I go back to the nose and soften the border between light and shadow. I work down to the tip of the nose, leaving the hard edge of the cast shadow under it. I soften and lighten the inside area of the lips, but I leave a hard edge on the top border of the section of upper lip that's out in the light. This subject has a pronounced "flap" of skin at the corner of his mouth, so I draw the dark wash down and join it up with the middle values on the left to indicate this. I add some background, using red to mellow my Hooker's green, and then I add some raw sienna and burnt sienna to the greenish wash. Before the eye areas are dry—when they're just damp—I add the suggestion of the eyelids and irises, using plenty of pigment.

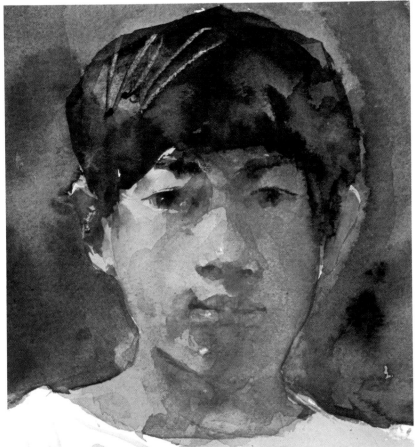

Step 4. Now I try to give more definition to some areas and some features, while I retain the soft, "lost" quality in other areas. (First, I finish the background, to keep the whole picture going at the same pace.) I paint the boy's white T-shirt, which gives the picture a pattern and design by contrasting strongly with the darker values of the head and background. I restate the hair, adding darker values in some areas and scratching out some strands. Next, I work into the eyes with a wet brush, lifting out a light strip where the lower lid is catching some light. I develop the mouth, leaving the darkest area at the left corner and breaking the division between the lips at several places. I work quite hard to define the chin and the darker area below the lower lip, putting in darks and blotting them with a tissue until the values are right. Finally, I add some shadow areas to the T-shirt, using lighter shadows here because the shirt itself is light.

Step 1. I use mostly red, with a touch of raw sienna, behind the hair. Skipping the ear itself, I use the same colors until I approach the eye area. Here, I rinse my brush and dip it into cerulean blue mixed with just a bit of water. Since I'm going to use wet-in-wet later, I brush almost pure pigment into the eye area. I add more red and raw sienna to the original shadow puddle on my palette and brush in some warmer color on the cheek. I'm working quickly, to make sure I get good blends. Now, I add more cool color around the mouth area. Since I'm going to restate these shadows, I don't worry too much if the warm-cool contrasts are too great at this point.

Step 2. The background at the front of the face is very close in value to many of the shadows on the face. So I paint in the background along this area and allow it to blend with the shadows on the nose and in the beard area. I'm careful to keep a fairly firm edge around the eye, since this area is more obviously separated from the background. I'll wait for the eye area to dry before I put in the background here. I work into the beard, using wet-in-wet. Some of the beard near the jawline is struck by light, so I'm careful to leave most of this area untouched. I use some dry-brush in the beard, being careful not to overdo it. I begin to wash in the light-struck area of the skin. This is where a little cadmium orange comes in handy; I add it to my very light wash for a very light area that still needs strength. (You might also try some cadmium yellow.) I start the hat, using cadmium red mixed with a little cadmium orange and burnt sienna. The red alone would be a little too raw.

PAINTING A MAN'S HEAD

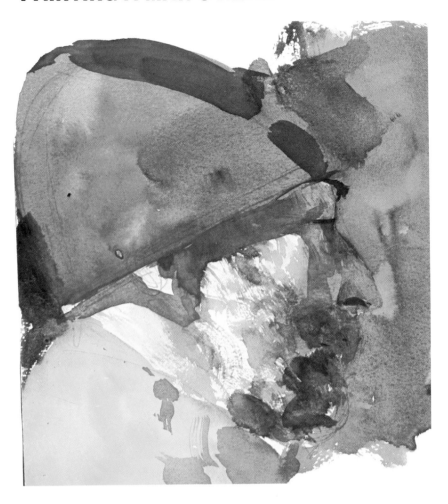

Step 3. Now, I begin to bring together. I allow my washes to dry so I can see where I stand. I add more background and start to define the nose and beard. I darken the beard with wet-in-wet, using cerulean blue, some burnt umber, and burnt sienna. It's hard to be exact here. I add the yellow foulweather jacket, and I place some of the important shadow shapes on the jacket when the first yellow wash is dry, using cadmium yellow light, mixed with a little orange. (Cadmium yellow medium might also work well here.) For the shadows, I use some raw sienna, some raw umber, and a touch of cerulean blue.

Step 4. I add my finishing touches now. As I said earlier, you can carry your final step just as far as you wish (but there is a stage at which—depending upon your abilities—you can reach a peak and start back downhill; so you should be ready to wipe out!) Don't let your picture harden as you approach the end. Keep some big blurs, like the areas I'm leaving in the hat and beard. As you start to scratch out in your final steps, don't indiscriminately pick away with your razor blade. Notice that the light-struck sections of this beard have a particular placement, which gives the beard form. Always be sure that your cast shadows describe the form on which they lie. For example, the cast shadow on the neck describes the round cylinder-like form of the neck. Notice the values in the shadows and in the cast shadows. They're dark enough to show that they're shadows, but light enough to appear luminous and airy.

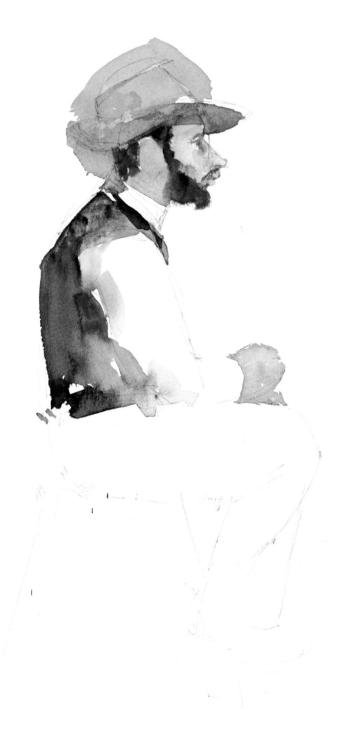

Step 1. First, I wash in the face with both warm and cool colors—more red in the cheeks, nose, and ears. The whole face, neck, and hands are more or less the same value. Next comes the beard. I don't make it too dark yet. I want the edges of the beard to make a gentle transition into the face values. Notice that I soften some of the beard edges with my brush. In some spots, the flesh tones aren't quite dry so the beard happily blends in at these spots. Next, I do the hair, using the same procedure as in the beard. The hat will have the most value changes, since the underside of the brim is turned completely away from the light, but it's still a good deal lighter than the beard. I leave the white shirt untouched except for the very back, where I allow some of the color to move into the collar to stand for the shadow. The vest is going to be consistently one value, with several colors used wet-in-wet. I use fairly pure color here, adding almost pure pigment into the damp area of the vest. I start with raw sienna and Hooker's green at the top; then I add some ultramarine blue to the lower sections of the vest. To lighten the shoulder, I blot a bit with a tissue while the shoulder area is still wet. I allow some of the vest color to flow into the sleeve area to soften the shadow areas of the sleeve. I blot with a tissue to make sure this doesn't get out of control.

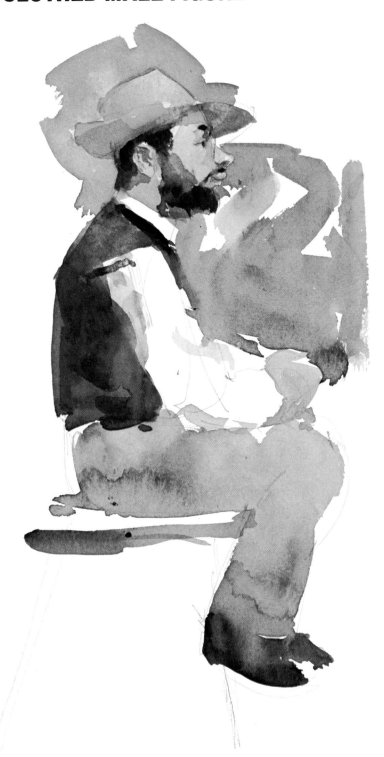

Step 2. I use a warm gray to wash in the canvas which is standing behind the artist. For this I use some cerulean blue, raw sienna, and a touch of red. As always, I'm concerned with shapes, and I make sure that the white area I've left has the feeling of a loose-fitting sleeve. I make the trousers a cooler gray, quite noticeably lighter than the vest; I use ultramarine blue, alizarin crimson, and a little cadmium yellow lemon. Finally, I add the shoes and a stroke to start the stool. Since the trousers are still wet, I have a soft edge between the shoes and trousers.

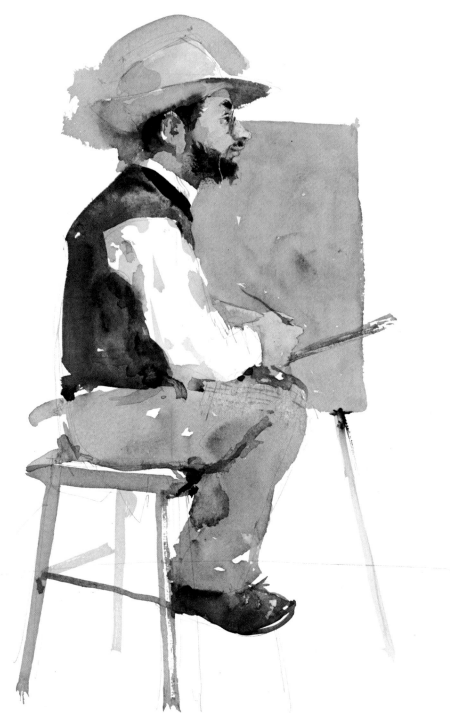

Step 3. Now all I need is to pull things together. I articulate the face more, going back into the beard in a few places with my darkest dark. I redampen the beard area with clear water; blot it a bit with a tissue; then add the darks wet-in-wet or with drybrush for the darkest darks. I use ultramarine blue and burnt umber here, but I don't paint darks up to the border of the face. I keep the darkest darks in the middle section of the beard and hair. I also add a few dark accents around the hands and legs. I don't use any folds except for a single indication at the knees. The figure has a convincing quality without any real indication of folds. Hard and soft edges are very important form makers in this picture, so I use very soft edges on the back of the hat and hair and around the shirt. I use only a few simple strokes to finish the easel and show the stool.

Step 1. The face is mostly in shadow. I start off with fairly dark values because the subject has a dark complexion, but I leave the light-struck nose untouched. I mass in the shadow areas of the hat with raw sienna and a touch of blue. As I move into the bandanna, I make the shadows cooler. I always use complementary colors for my grays, and here, I use blue with a touch of orange, and some purple with a touch of yellow. Some of the bandanna's shadows are pure blue. I use a spontaneous approach, although I carefully plan where the wash will go. I wait a few seconds to let the blouse areas dry before blocking in the neck. Some blending is good, however, so I don't wait too long. I next wash in the flesh tones of the neck and right side of the blouse, which are in shadow. I add the background. Hard edges are desirable on the left side, which is in sunlight, but I want softness on the shadow side, so I add the background while the shadows on the blouse are still wet. I add the hands and adjoining cast shadow under the left hand. I make a soft edge between the left hand and the adjoining shadow.

Step 2. I go back and relate the face to the underside of the hat. To give the face a raking light, I lift the major light in the right cheek and forehead with a dampened tissue and wait for this area to dry before working into it again. I restate the neck, then as I start to develop the underplane of the breast, I see that I've made a mistake and put a dark where the light-struck area should be. I dampen a tissue with clear water and lift out this dark. After it dries, I restate the shadow on the underside of the arm. I don't make a solid plane, but to suggest the folds, I make several smaller, dark indications. I darken the underplane of the hands and further develop the cast shadows on the skirt. Now, I go on to the very difficult folds in the upper right arm and shoulder. I make sure that my value consistency and color are correct in the mixture on the palette. Then I give each single stroke considerable thought so that it will explain the cloth as well as the overall form of the area. I brush in more of the background.

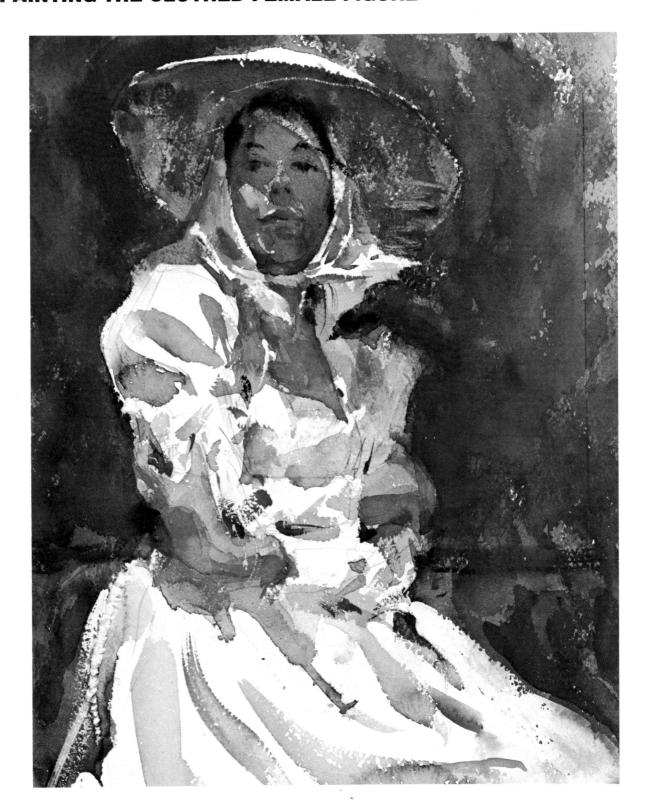

Step 3. I stroke in the folds on the skirt. It's a very full skirt with an involved pattern of folds. Again, I try to put in only the most important folds, and these I do with care. Even though these strokes look like they're dashed in, this really isn't the case. Each stroke is planned and given careful thought. I go back to develop the feeling of light in the face. Some of the small lights are scraped in carefully with my razor blade, but I don't dig up the paper. I try to just lift off the color. Razor blade work is fine, but I don't overdo it. I sponge off larger light areas with a tissue and then restate them. I add touches of opaque white to pick up light-struck areas in the dress and scarf and to make the right side of the skirt seem fuller. For other light-struck areas, I use a razor blade. Using drybrush, I indicate some bracelets with some cadmium yellow pigment. Finally, I finish the background, softening some edges and hardening others in the boundaries of the figure.

Step 1. At this stage, I'll mass in the basic colors and establish the colors that will dominate the painting. I begin with the face, which is quite light because it's in strong sunlight. Then I wash in the hair with burnt sienna and cerulean blue, using a great deal of pigment. (The face wash wasn't quite dry, and some of the hair color ran into it. I'll blot this with a tissue.) While the neck is still damp, I wash in the sweater with phthalo blue, alizarin crimson, and burnt sienna, allowing the colors to blend on the paper. It doesn't really matter which colors I use here, as long as they're dark.

Step 2. The sweater is still wet as I add the background, and you can see that the two areas blend together. (This is a very good idea when you place two very similar values next to each other. Just use plenty of pigment and keep shaking the excess moisture out of your brush to keep such areas rich and dark.) I use a tissue to wipe out and soften some areas, including the light-struck lower right portion of the figure. Notice the number of soft edges at this stage; the painting is very fluid and loose.

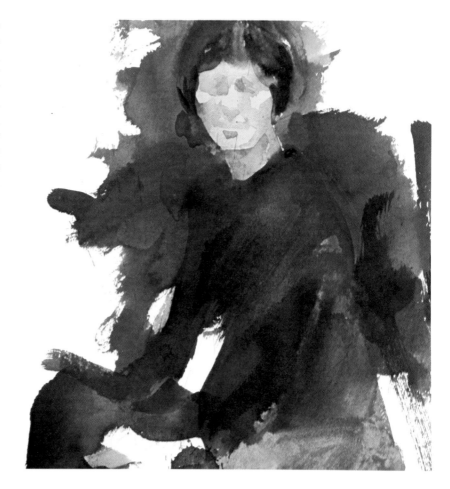

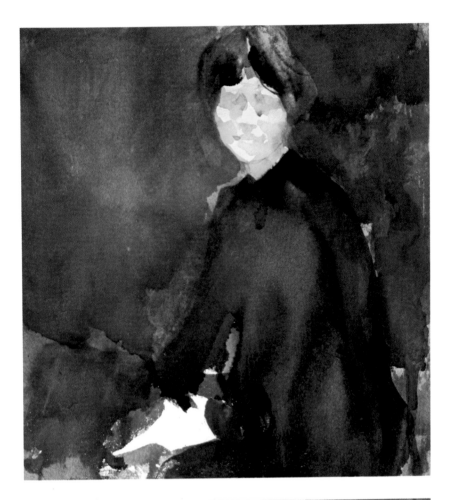

Step 3. I complete the background, keeping a great deal of softness throughout the picture. I leave the area of the hands untouched for now, along with an area on the ground, because these will be the lightest areas of the picture. (I used a bit too much water in my clothing mixtures, and the sweater has become too light. I'll restate it at a later stage.) I carefully articulate the more definite shadow shapes in the face, trying to indicate the major planes of light and shadows and not worrying about the details.

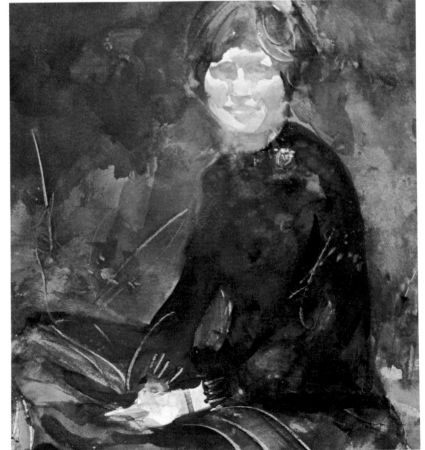

Step 4. I bring the face into focus, adding a minimum of detail around the eyes and mouth, and allow the eyes to play a secondary role to the lights and shadows. I add some light wash to the hands and restate the clothing, leaving it slightly higher in key than I would normally make it to indicate that the figure is bathed in light. I scratch out some details on the clothing with my fingernail and a brush handle and use a tissue to wipe out some highlights on the light-struck sections of the knees and upper legs. I restate the grass using greens, mixed with blue and raw sienna, scratch out some texture with my fingernail and a brush handle, and add more texture by spattering.

Step 1. Starting with the figure on the left, I paint in the warm shadow areas of the face. Working quickly and not worrying too much about colors running together, I add the hair, using a touch of phthalo blue and burnt sienna. Some of the hair color runs into the face, and I blot the face area with a tissue. Next I paint the red towel that the boy has around his neck. I use pure cadmium red. For the shirt, I want to take advantage of my white paper so I dash in only the important dark folds. I also brush in some blue for the sky, again to help make the white stand out. I want to establish the darkest darks early, so I add the dark accents in the trousers and hatch. Here I use phthalo blue and burnt umber. The values in the sail bother me, so I use a middle value gray. I'll probably have to go darker here, but for now I just want to cover the paper.

Step 2. I wash in the sail, trying to work in some good color variety. It's important to be courageous in this stage. With drybrush I work in the boom running along the bottom of the sail. I want some blend, but I also want to avoid too much of the dark color from the boom running up into the sail. I start working on the other figure, leaving the white shirt untouched. I wash in all the skin tones with the same color and value, keeping the colors rather warm. While the skin tones are still wet, I blot the knee to lighten it. The very dark values in the hatch are painted in with phthalo blue and alizarin crimson. Finally, I wash in the side of the cabin under the left-hand figure with a light, cool gray.

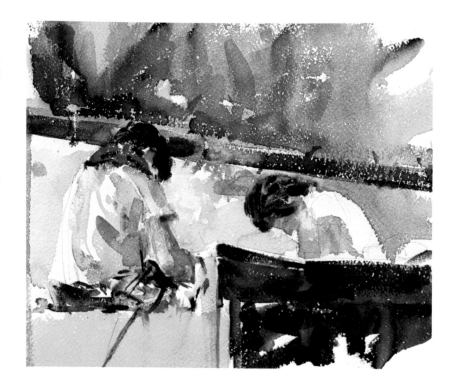

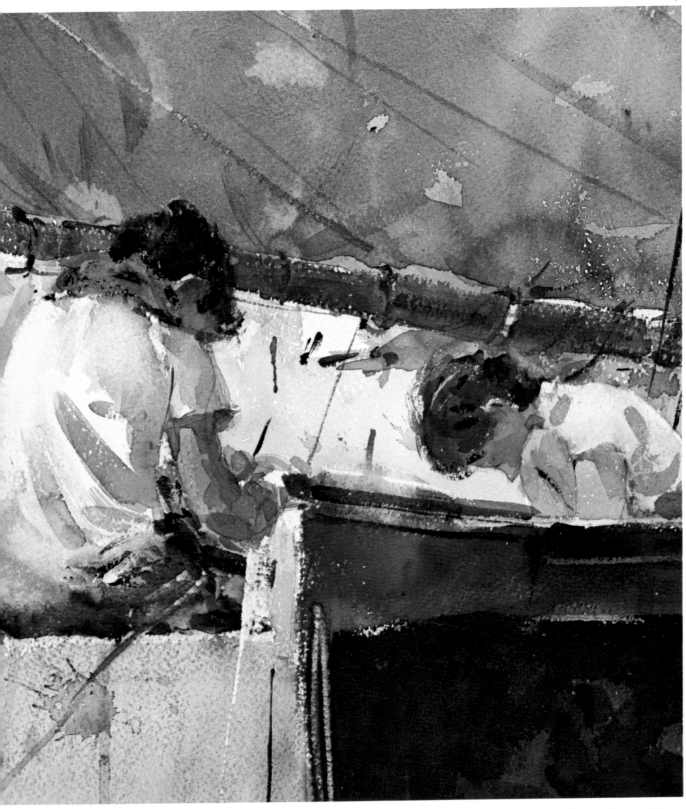

Step 3. I finish off the dark hatch and decide to go for darker values in the sails. I spend long moments looking at an area like this when I'm not sure of it. I hold my hand as if holding an imaginary telescope and stare through the hole. Sometimes I practically stand on my head, hoping that a new point of view and perspective will give me the answer. One advantage of working on the spot is that you don't agonize over the areas like this quite so much. The folds on the girl's shirt seem spontaneous, but they've been carefully thought out. There are only two values here—the overall value of the shirt and a single darker value for the shadows. I add some dashes of orange pigment for the highlights of the scarf. The trousers of the figure have become too heavy and dark and the last thing I do is sponge out the lower section of the torso, extending the shirt.

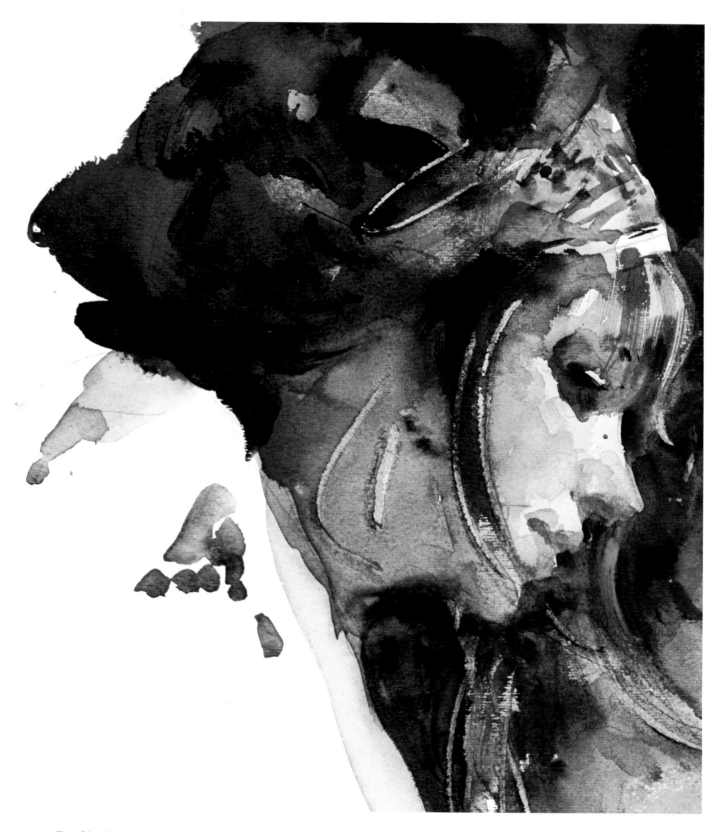

Eye Shadow. 10″ x 14″ (25 x 35.5 cm), Fabriano paper. This girl had a very sensitive and delicate face. I tried to enhance it by surrounding her with dark values, framing the light-struck face with the dark background and hair. There are really no value changes in the face, but the definite shadows and cast shadows around the eyes, nose, and mouth create all the form necessary.

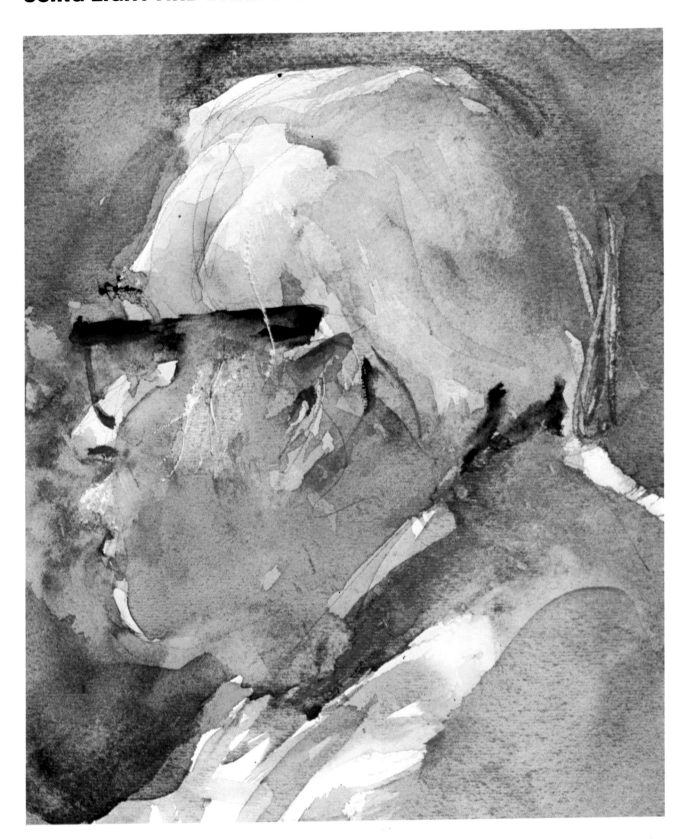

Eddie. 10″ x 10″ (25 x 25 cm), Fabriano paper. This is a picture of one of the artists who works in our sketch group. Here, to capture the feeling of strong light shining down on the subject, I used definite shadows and left the background high in key—actually higher in key than seemed right at the time. Adding dark values to a background can destroy the feeling of light and atmosphere in a painting. Try to find a value that's just dark enough to offset your light values, but not so dark that it will destroy the feeling of light and atmosphere that's so important in any painting.

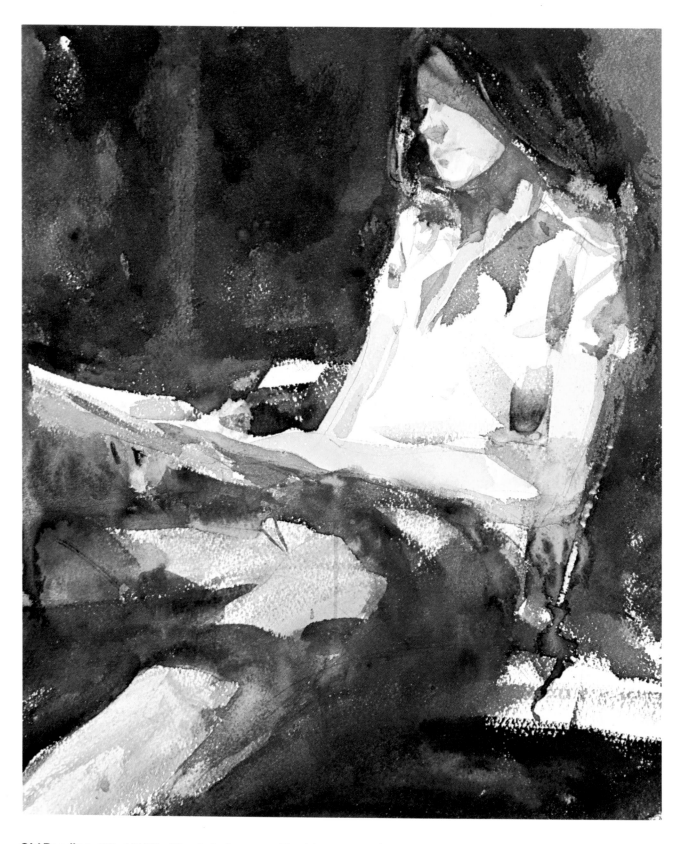

Girl Reading. 15″ x 15″ (38 x 38 cm), Arches paper. The skin tones are washed out and close in value to the white skirt, but even so, there's a difference, and I established this difference at the beginning of the painting. I painted in all the skin tones with light values and allowed them to dry before adding the shadow shapes. While the shadow shapes were still damp, I painted in the hair so some of the soft edges that are important in shadow would happen. The background is mainly burnt umber with a little blue added. I also used Hooker's green and burnt sienna. The shadows in the shirt were predominantly blue, with a little umber mixed in to lower the intensity. I left the shirt as simple as possible because the white paper is effective in communicating the feeling of sunlight.

COMBINING LIGHT AND DARK VALUES

Step 1. Using a warm combination of cadmium red and yellow ochre or cadmium yellow lemon, brush in the figure freely, starting with the head, shoulders, and arms.

Step 2. Add cerulean blue across the upper part of the chest while the warm wash is still wet. Allow the blue to blend with the warm tones. Draw the wash down the torso to the beginning of the upper legs.

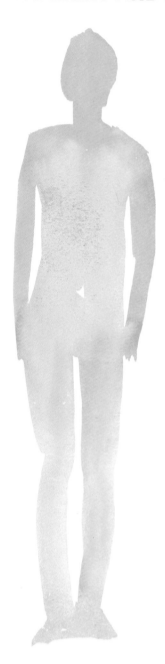

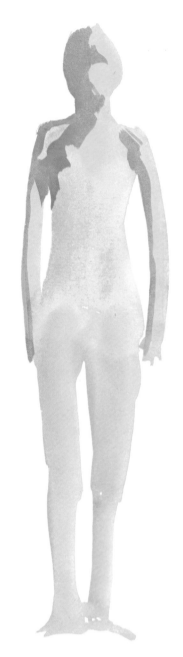

Step 3. Go back to the water jar, and rinse and shake your brush. Load it with the warmer color, and quickly return to the figure. Block in the legs. The figure should be very free in terms of boundaries. Don't worry about drawing here, just color. Let this first wash dry.

Step 4. Mix up the darker values on your palette, using cadmium red light, raw sienna, and a touch of cerulean blue or Hooker's green. Block in the shadow of the head with the red definitely dominating; draw the color down into the neck, jogging over to the shoulder, and indicating the upper chest and arm areas which are to be in shadow. If you find that the raw sienna is taking over, dip directly into the red on the palette, and add it "straight" into your shadow wash. Be brave! It will dry and won't look quite so strong.

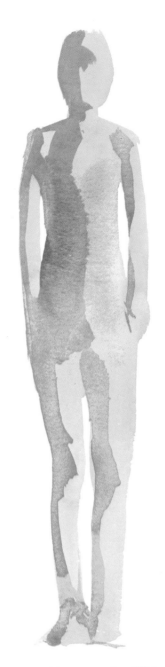

Step 5. Go back to your water jar and rinse your brush, giving it a shake. Go heavy on the blue or green. Use strong color, but make sure you don't have too much pigment. Good paint consistency means a happy medium between lots of pigment and just enough water to make it flow well. Starting well up in the shoulder area, block in the cooler torso area shadow. Notice how freely these shadows are indicated. Now's the time to enjoy yourself and revel in color without worrying about careful drawing and construction. Brush in these cool shadow areas freely, down to the upper leg area.

Step 6. Back to the rich, warm color. With a full brush, start at one of the knees and brush the warm color up and into the cooler wash. (You could start from the cool middle section of the figure and work down the legs with the warm colors. It isn't important which procedure you take. I'd suggest you try one way now; experiment later with the other.) You should have enough color in your brush to finish off both leg shadows. Cover the left lower leg completely with shadow color. This makes the knee look bent, an example of shadows helping to explain the positions of the forms.

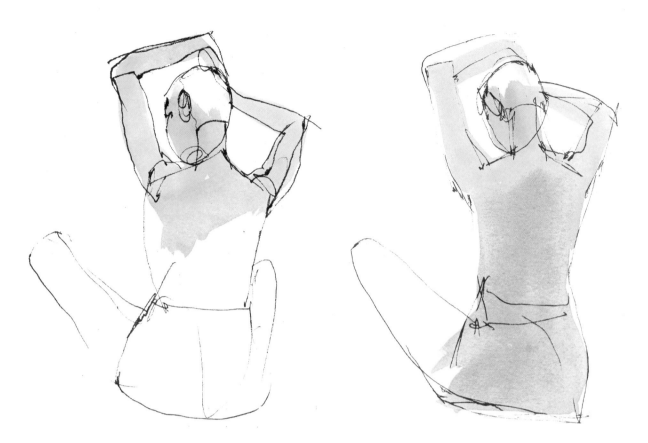

Step 1. Make a light sketch of your figure, not a careful rendering. Make your drawing about 10″ high. This is a good average size, not too big to cause proportion problems, but big enough to allow freedom in your brushwork. Your sketch should be only a guide for your wash. The lines you make should not be just filled in. If the drawing goes badly, erase and make some corrections, but don't overdo this. I genererally start my drawing over rather than correct it, since erasures disturb the paper. Washes won't sit nicely over a heavily erased area.

Step 2. After you're satisfied with your drawing, select a brush and, after rinsing it, make a warm puddle of cadmium red and cadmium yellow (or yellow ochre) with just a touch of cerulean blue or Hooker's green. Fill your brush from this puddle, give it a good shake, and start washing in the upper section of the figure. This is the same procedure you've used in earlier color projects, but this time you'll try to create good shapes. Block in the head, then the thinner neck. Continuing with the warm wash, include both shoulders and arms. Watch the shapes. Note the difference between the shapes on one side of the form and the shapes on the other side of that same form.

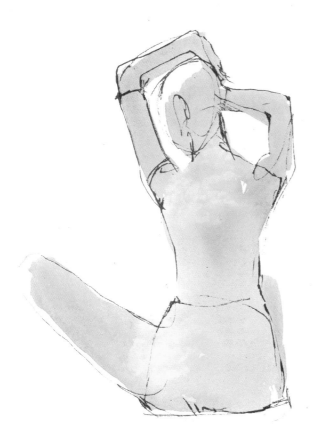
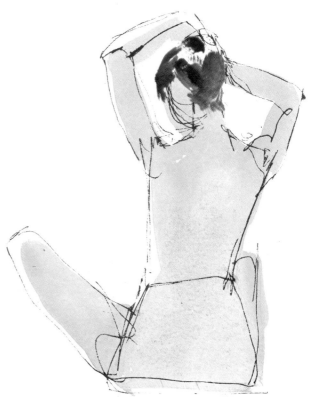

Step 3. Cover the whole torso area with cool tones. Cerulean blue or Hooker's green will be the major color here mixed with a small amount of the warmer mixture. Work fairly quickly to get a good wet-in-wet blend between the warm and cool areas.

Step 4. Back to the warm colors. Start with the left knee and brush toward the cool torso. Finish the legs, getting a blend between the cool lower torso and warmer legs. Probably the wash will still be damp, so blot the hip and upper torso a bit to lighten these two areas. They will be the lightest lights in the final stage. Allow this to dry.

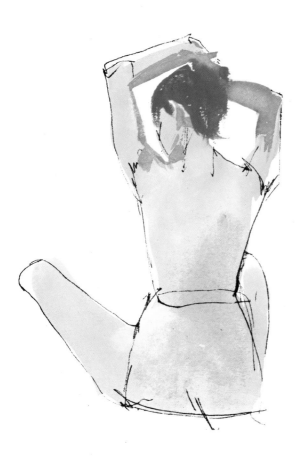

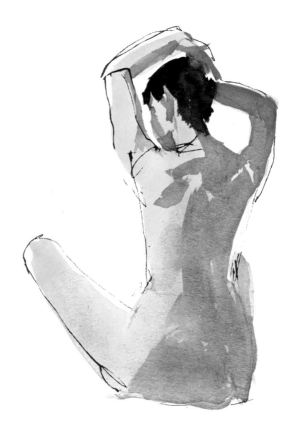

Step 5. Now add the shadow shapes, using the procedures discussed on pages 55–57. For the dark hair, mix up a combination of burnt sienna and ultramarine blue. You might also try it with some alizarin crimson and Hooker's green. Experiment! Don't always use the same two colors. Darks are the place for rich color. Mix the darks on the palette, start blocking in the area, and then add some pure color wet-in-wet. Let some pure blue, green, or alizarin show. Don't feel that everything must be blended.

Step 6. While this is still wet, go back to rinse the brush and mix up the shadows. Use a combination of cadmium red light, raw sienna, and cerulean blue or Hooker's green. In this particular pose, the hands are the natural beginning between the dark hair and the adjacent shadows of the left hand and right upper arm. Starting at the wrist, carefully articulate the thumb with a graceful little touch. Allow the warm, dark color to blend with the hair. Now back to the water jar, and give your brush a rinse in case you picked up any of the hair color. Finish both arms. The left arm has very definite shadow shapes which describe the arm's muscle structure while the right arm has a simple shadow silhouette.

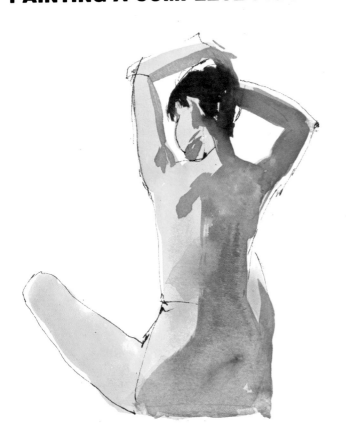
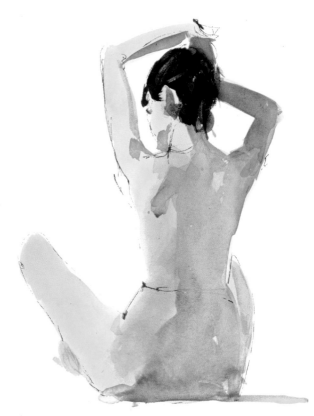

Step 7. Be concerned about shapes. The structure of the back is at once very broad and simple, but also quite exact in explaining the structure and conformation of the back. The straight form of the shadow on the back—as opposed to the curving shadow on the lower torso—is interesting. Continue with the cooler shadow areas here. The cerulean blue or Hooker's green should dominate. Don't put any small darks out in the light except the dark that indicates the underplane of the shoulder blade. This is a small dark, but a very important one. Soften the lower ribcage with cleansing tissue or your brush after it has been rinsed and shaken, and allow some of the shadow to flow out into the light. Add warm shadows in the right leg. Leave the left leg untouched.

Step 8. Allow all this to dry before adding the few middle tones. The major decisions are made; these few middle values are not only for the sake of finish, but also for the sake of explaining areas that need help. Shadows should be a simple, single value if possible, but sometimes you need to add further darks. In the case of the right arm, it doesn't recede enough if it has the same value as the rest of the shadows. Add a darker overwash here. Softening the shadow edge is usually sufficient for making middle transition values.

Let's add another value to finish the figure and to make some of the transitions from light to dark more subtle or more definite. Use a wash somewhere between the shadows and the lights for this additional tone. Add this middle wash over the shoulder blade from the shadow up to the neckline, describing the shoulder blade. Add a middle tone in the lower torso to stress the roundness of this form.

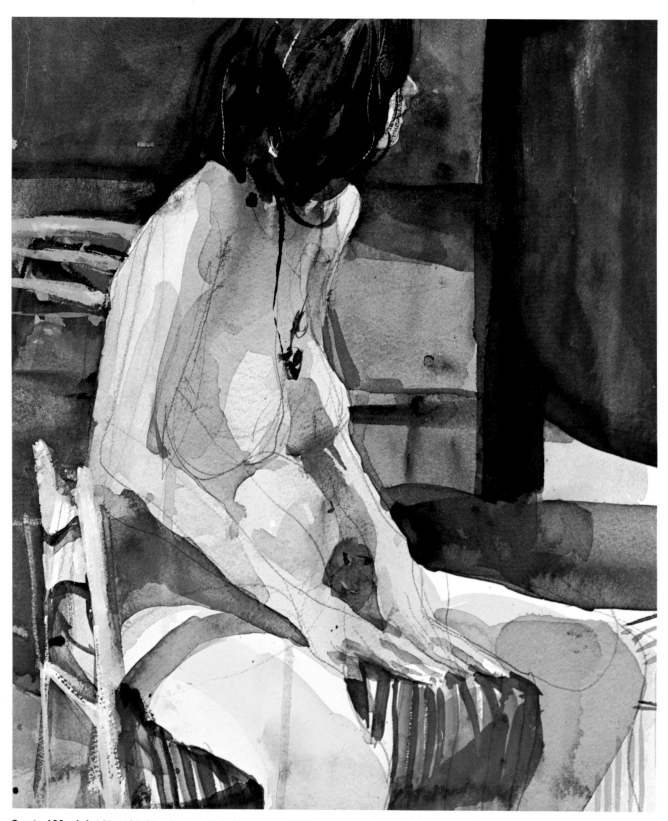

Seated Model. 15″ x 12″ (38 x 30 cm), Fabriano paper. This painting was done in a sketch class. I paid a great deal of attention to the relationship of the figure to her surroundings. I tried to think of the figure as an area of light and as a shape surrounded by other shapes. As in most of the sketch class paintings that I've done, the colors are stronger and more vibrant than in the paintings I do from sketches or photographs. The use of strong reds is obvious here. There's also a roughness which comes from working quickly and spontaneously. I think this roughness is attractive, and I like this picture's rather crude, unfinished quality. I was also interested in the strong horizontal and vertical shapes which lead the eye through the picture. Notice how the dark shape on the right helps balance the figure. I've tried to contrast patterned areas with broad, simple, plain areas. Notice the use of stripes in the chair and in some areas of the background.

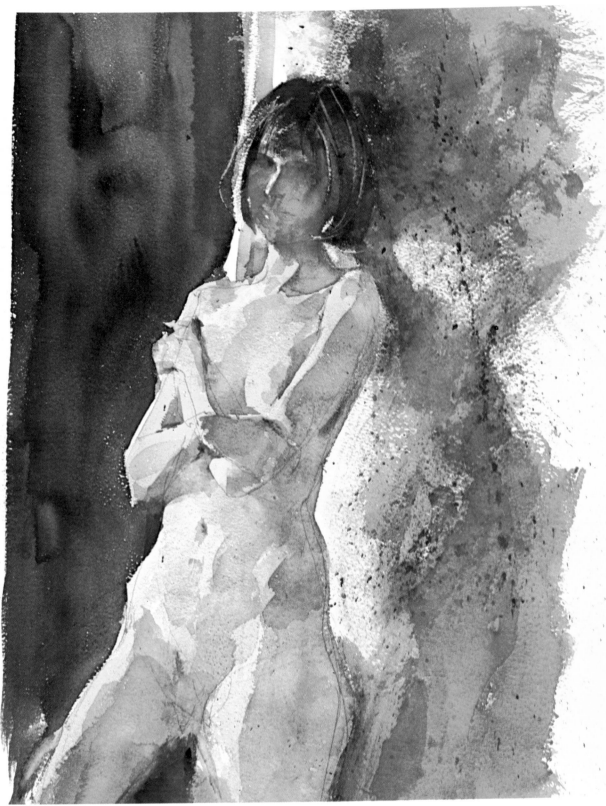

Standing Figure in Sunlight. 18″ x 15″ (46 x 38 cm), Arches paper. I like the mysterious quality of the face in this painting. The girl's hair kept most of the face in shadow, and only the nose and a little section above the eye picked up any light. The flesh tones are neutral, especially the torso areas which are mostly cerulean blue. I did the background with burnt umber and phthalo blue with a little alizarin crimson added. The wall is rough, so I used drybrush to create a pebbly effect and then applied some shadow work. My colors were raw sienna and some burnt sienna with a little blue added in the wall to the right of the model. In the figure I left hard edges to accentuate the angular quality of the subject. With my fingernail, I scratched out a few lights in the hair while it was still wet. The hair and the adjoining skin tones have no clear-cut division because I painted the hair while the skin was wet.

Step 1. Sketch in the figure, using your 2B pencil. Never rush through the drawing stages, but be concerned with good shapes. Even though your sketch is very lightly drawn and certainly won't be followed exactly, always be as descriptive of the actual forms as possible.

Step 2. Mix up the light washes on your palette and block in the figure. There should be obvious differences between the warm and cool colors. For the hair, work directly with pure color, instead of mixing the color on the palette. This is especially good in working with dark hair. Add the hair color wet-in-wet, perhaps dampening the paper first; burnt sienna and ultramarine blue are the main colors, but a touch of alizarin crimson and Hooker's green might be used too. The color will dry lighter, so use plenty of pigment with just enough water to make the color move and not "cake-up."

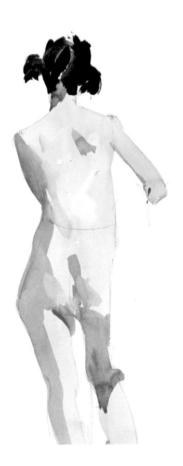

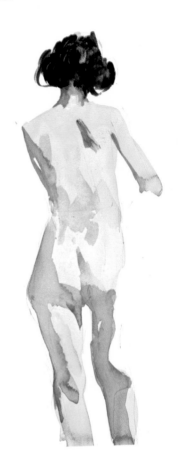

Step 3. As it happens, the shadows take up very little of the figure area, but still mass them in carefully, making sure they express the form of the body. Work quickly, softening some of the edges in the middle back (where the upper and lower torso meet) and in the buttocks, allowing some shadow color to work out into the lights.

Step 4. Quickly add some cool middle values to the base of the spine and the lower back. Always keep a tissue handy in case this gets too dark or too important. Keep these middle values definitely lighter and less important than the shadows. There could be many other middle values definitely lighter and less important than the shadows. There could be many other middle values, but omit them to keep the figure simple—uncluttered and broad. You can't really judge how to finish the figure until you've added the background. When the background is finished, the figure may require more work, but wait and see.

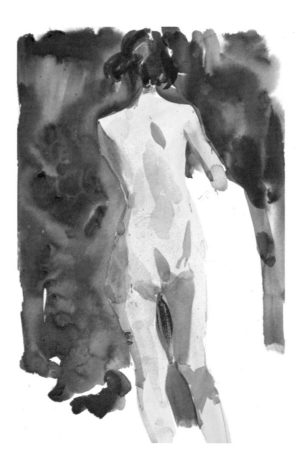 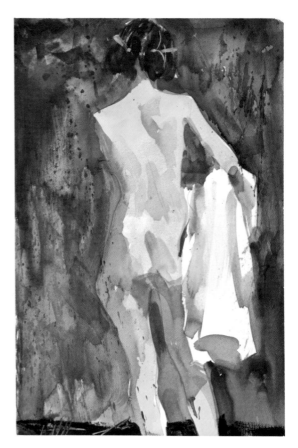

Step 5. While the shadow is still damp, start scrubbing in the background, working the brush into the paper with a variety of strokes. Use burnt sienna, Hooker's green, some burnt umber, alizarin crimson, or any dark color. Yellow ochre or cadmium orange would be too light and the values would not be dark enough. Carefully describe the outside shape of the left shoulder which is in the light, but work quickly to make a soft edge where the left side of the torso and arm are in shadow. The edge between this shadow area and the background should be nice and soft. At the same time, work the background color carefully around the light boundaries.

Step 6. When the background has dried, use two almost parallel strokes to indicate the cloth that the model holds and soften them with a tissue. Use a short stroke to show that the cloth is draped over the arm. The bulk of the drapery can be suggested by a simple, circular stroke at the bottom. If the dry background needs some more color variety, brush a clear wash over it, and after the wash sits a moment, drop pure dark colors into the damp areas. For texture on the wall, I use "spatter" work. First, I mask off the figure by holding a piece of paper over it. Then, to spatter the paint, I load the brush with color, and knock the handle against my finger to stop the brush abruptly and make the paint spatter on the paper.

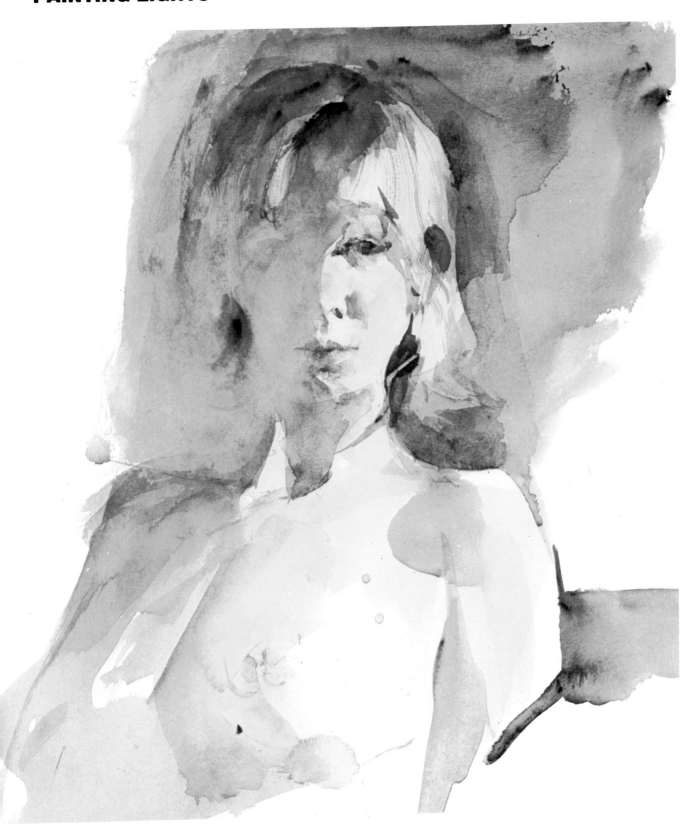

Karen. 12″ x 14″ (30 x 35.5 cm), Fabriano paper. This model was quite nervous, and she was sitting very stiffly. Her head was held back, and the tendons in her neck came into sharp relief. I like to find the particular aspect of each painting that makes it worthwhile. I always look for the offbeat gesture, feature, color, etc., that separates one painting from another and adds some particular interest to it. This girl had very blonde hair, and I used a combination of cadmium yellow pale and a tiny bit of yellow ochre to wash in the light sections. Then I blotted the area with my tissue. Blonde hair is difficult to paint because it's often darker than it appears. Even in this very blonde hair, there were some very dark areas. It's also important not to overwork the light areas in a painting such as this. Try to keep the very high-keyed sections—in this case, the very blonde hair—uncluttered by small value changes.

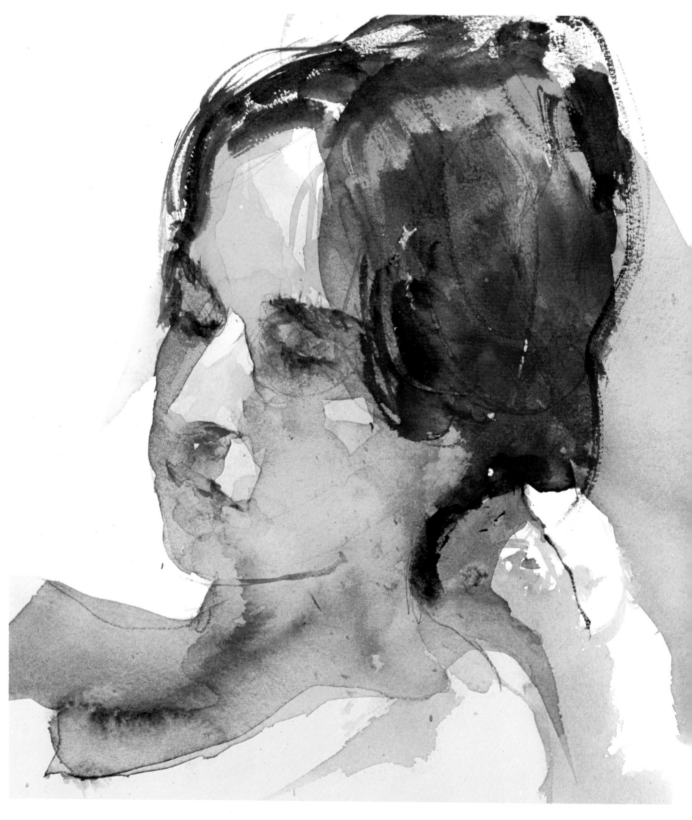

Tuesday Night. 10″ x 14″ (25 x 35.5 cm), Fabriano paper. The model had very sharp features, enhanced by the strong single light source. Note the carefully developed shapes in the nose, for example. The nose is actually the most important feature in this particular sketch, and I gave the shapes within it particular attention. I left the lights very high in key, but suggested a slightly darker value on the light side of the nose. This value change was necessary to show the construction, but I was very careful not to let it become too dark, or I would have destroyed the feeling of light and form in the head.

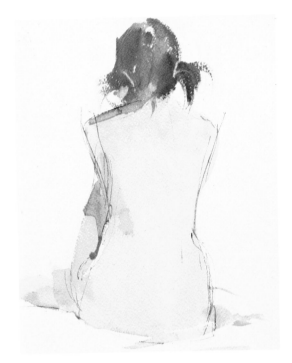

Step 1. I sketch the figure in with a 2B pencil on rough Arches paper. The sketch is quite lightly done, and I keep my pencil work free and spontaneous. I stress the broad shoulders, which make very attractive shapes in relation to the rest of the figure. I make the right side straighter than the left side. (Make sure you study and understand the shapes.) I lightly sketch in some drapery.

I paint in a light first wash. Since the model has fair skin, there are no dramatic color changes, and I use the same colors I've mentioned: cadmium red light, cadmium yellow lemon, yellow ochre, and cerulean blue.

Step 2. For the cool gray in the drapery, I mix a touch of cadmium orange with the cerulean blue. I start the torso with warmer color in the arms and shoulders, and the color becomes cooler as I add more cerulean blue. For the hair, I use burnt sienna and ultramarine blue. An area like the hair should be as rich in color as possible, since it will always be less exciting when dry. I use the wet-in-wet technique, adding pure color directly from the palette. Next, I mix a shadow wash, using cadmium red light, raw sienna, and a touch of cerulean blue and Hooker's green. The cast shadow runs along the left shoulder. I block in the large shadow which describes the border of the torso and a section of the leg. It's important to generalize shadows in this way. I never paint two separate shadows for adjoining areas, but I always mass in as much shadow area as possible with a single wash. I soften the shadow as it reaches the waist area, and I allow some of the shadow color to work out, forming a middle value. The construction of the back is complicated so I avoid most of the back's small forms.

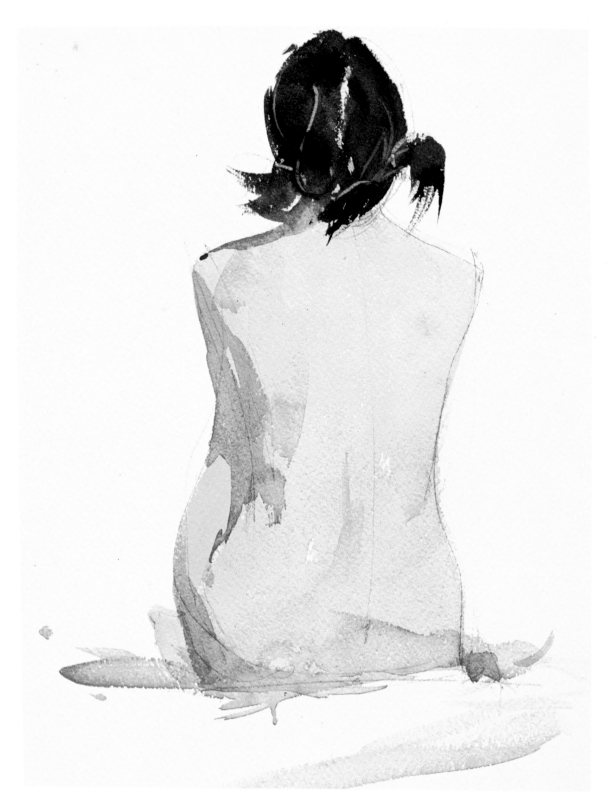

Step 3. The hair has dried too light and dull. I pass a clear wash over the hair, blot it a bit with a tissue, and let it sit a moment. Then I restate the darks, using blue and burnt sienna. To see if I can make the color a bit richer, I add a touch of burnt umber and Hooker's green. I blot the hair in one or two places to lighten those areas that need lightening. Then I scratch out some indications of hair strands with my fingernail. The darker, richer hair sets off the figure much better now. I don't want to confuse the lights with small darks that will "break up" the big, simple form of the figure. So I mix up a light puddle and indicate a few more of the important middle values. The shoulders are held forward, creating an important side plane in the form of a curve, reaching roughly from the left hip bone to the inside edge of the left shoulder blade.

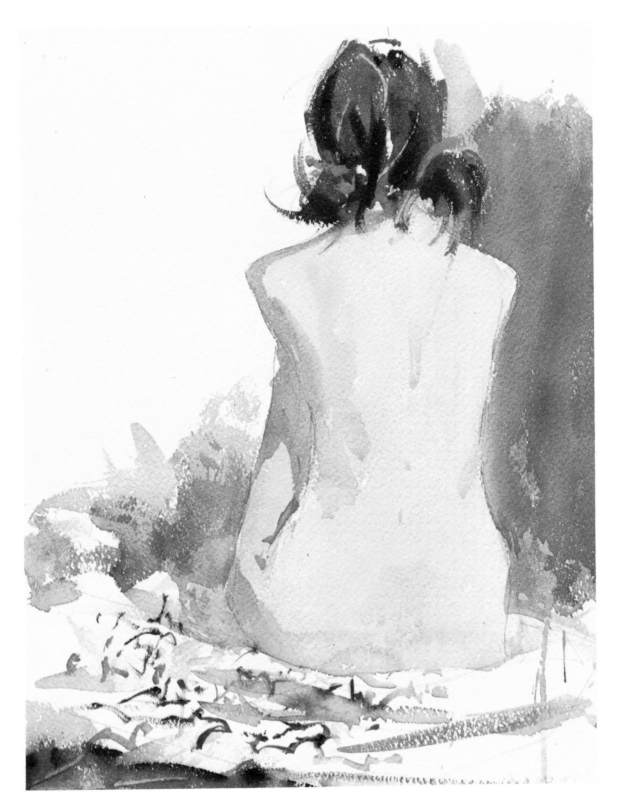

Step 4. I keep the background very high-keyed to enhance the airy, light feeling I'm after. I want a cool, neutral color back here. I use some ultramarine blue, alizarin crimson, very little cadmium yellow lemon, and in the lower sections, Hooker's green and cadmium red light. I keep a tissue handy for blotting and lightening. The edges are given special attention—harder edges face the light, while soft, lost edges are found away from the light and in shadow. I don't finish off the entire background, but the completed part forms a diagonal curve through the picture. The figure itself is very simple and seems to need something, so I add an indication of pattern in the drapery. I also add some pure pigment to indicate hair ribbons. This gives a nice color accent in the upper section of the figure.

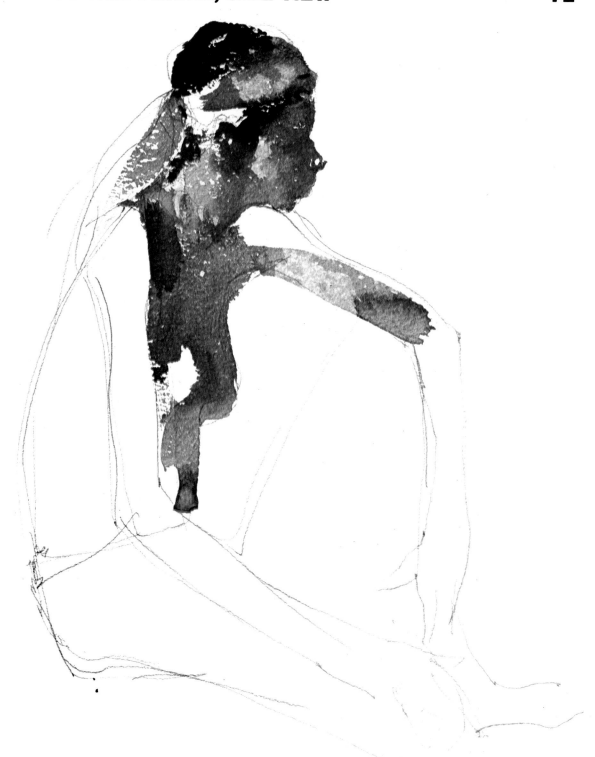

Step 1. I start off with the forehead, using a rich, cool wash of
ultramarine, raw umber, and a touch of red. I try to make
this first wash dark enough with the first try. I work around
certain facial areas to leave white paper for a light-struck
effect. I soften some of the edges of these light-struck areas
with my brush and a tissue. I work with warmer colors as I
get into the cheeks and nose. Painting wet-in-wet, I start
using cooler colors in the chin and around the mouth. I make
obvious color changes in the head, and I go on to the neck
and torso. I blot the left arm to lighten it.

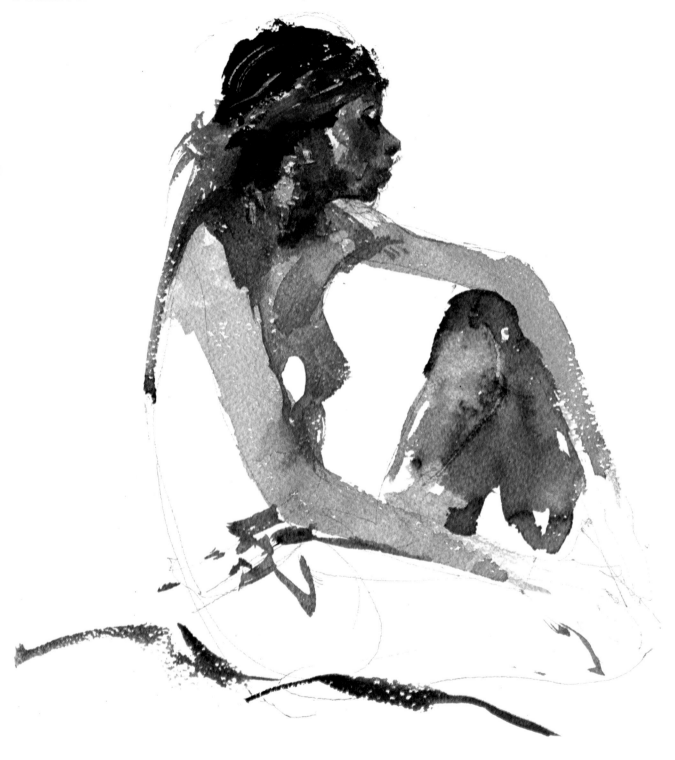

Step 2. The front of the torso is dry now. I go on with both arms, but I'm also working on the head to bring it toward a finish even before the rest of the figure is completed. I work in wet-in-wet and add overwashes. I try hard not to disturb the previous washes, but this doesn't stop me from working into areas that I want to change. Using this approach means that I'm going to lose quite a bit of the freshness that I usually enjoy, but I don't worry about it here. I'm aiming for subtlety and complexity.

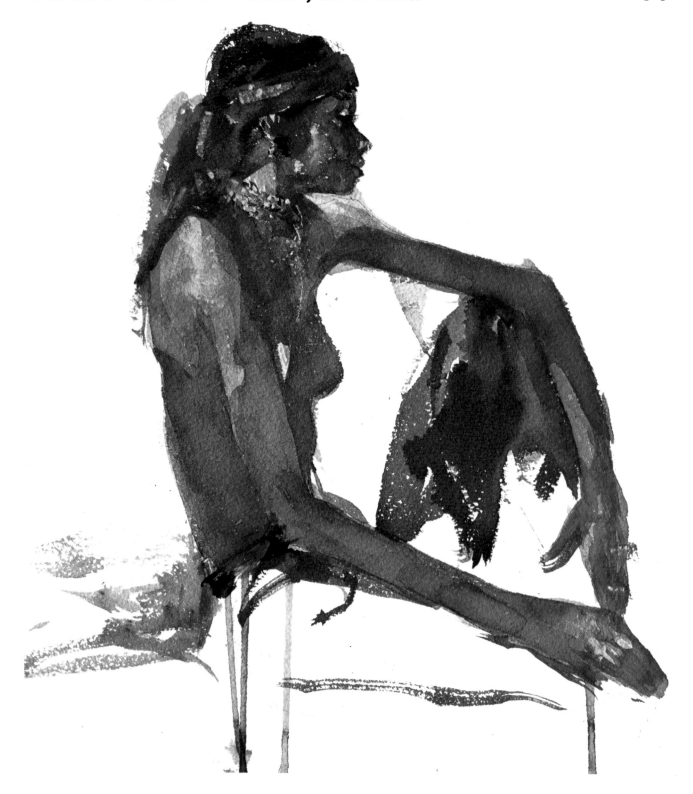

Step 3. I continue adding overwashes. I want to get the feeling of raking light across the figure. I develop and pin down my light-struck areas—hardening some edges, scratching out more light where necessary, and in other places "losing" edges. I work for a feeling of the definite and exact in company with the indefinite and nebulous. I first dampen the headband and then lift out lights with my fingernail. I scratch out lights in the skin tones and add pure pigment for the ring and necklace.

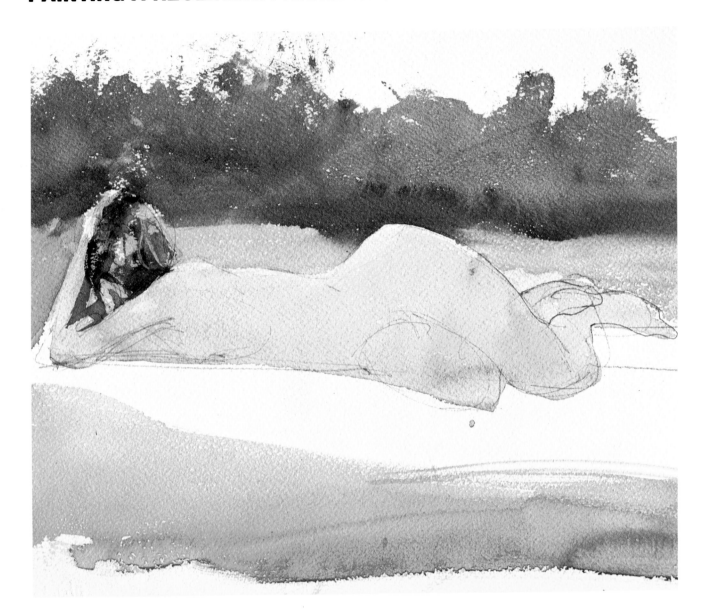

Step 1. I wash in the whole figure with my first wash, using my basic colors: cadmium red light, cadmium yellow lemon, and cerulean blue. I want this figure to be "swimming" in sunlight, so I keep the first wash quite light, but as rich as possible. Around the figure, I use mostly cadmium yellow lemon, with just a hint of cerulean blue for the grass. The distant trees are a combination of cerulean blue, cadmium yellow lemon, and raw sienna. I leave the white cloth untouched. The white paper will stand for this area. As the lights are drying, I start thinking about the shadows. I'll stress color changes rather than value changes, so I want both the lights and the shadows to be extremely simple. As soon as the light areas are dry, I wash in the warm darks and carefully articulate the shadow shapes in the complicated area around the head and forearms. Next, I indicate the shadow areas of the hair with burnt sienna. I scratch out a few hair strands with my fingernail.

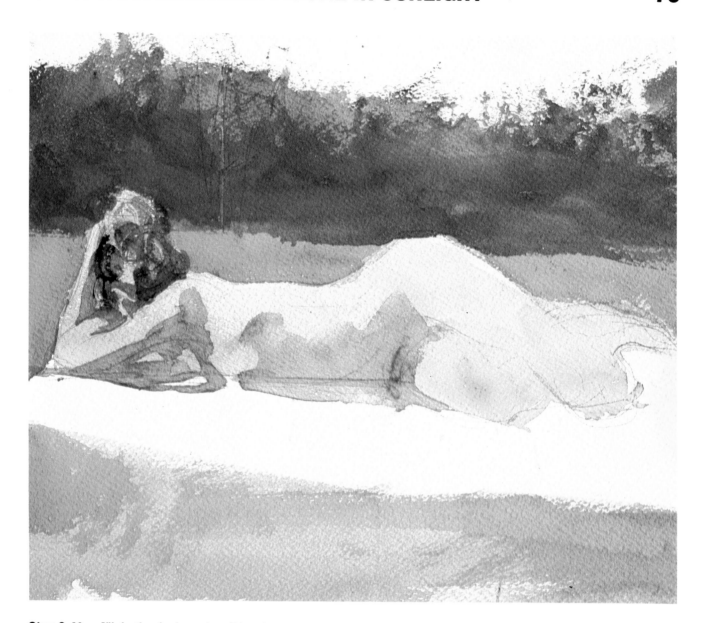

Step 2. Now I'll do the shadows describing the upper arm and torso. I paint the cast shadows on the cloth at the same time as the body shadows. Warm reds and yellows in the elbow area give way to much cooler color (cerulean blue) around the shoulder and torso areas. I use mostly cerulean blue with a touch of yellow or orange added for the cast shadows. I allow the shadows of the flesh tones and the cast shadows on the cloth to blend together. I make the large shadow on the upper and lower torso high-keyed, but since the very light cloth reflects into this large shadow area, it stays quite cool. I give careful attention to the shape of this shadow. Also I add some darker values to the background.

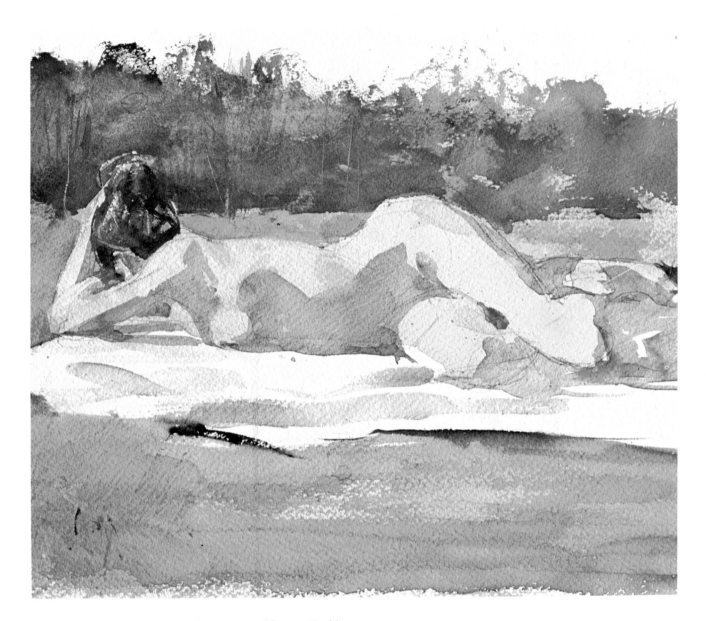

Step 3. I complete the shadows in the legs and feet and I add the cast shadows. Now I go back and add a few middle values. The plane of the ribcage and shoulder is made very subtle, since I don't want to disturb the simple light-shadow relationship that gives the figure a feeling of light. The few important folds in the cloth are indicated. Again, a minimum of strokes! I add the finishing touches in the landscape, and it's done.

Step 1. The colors are: cadmium red light, yellow ochre, cadmium yellow lemon, and cerulean blue, and I mix all of the colors on the palette. I use the warmer tones in the shoulders, arms, head, and legs. I mix a little cerulean blue on the palette with the other colors for the torso, where the cerulean blue dominates. I wash in the hair with a little cadmium yellow lemon and yellow ochre. I want this to be light, but I let the cadmium yellow dominate to give warm, light areas in the hair. However, blonde hair isn't truly yellow, but quite neutral, so I keep the cadmium yellow in check with the ochre.

Step 2. Here I add the first shadow shapes and the major planes. With a single wash, I very carefully block in the shadow on the arm and the dark area between the face and left upper arm. The shadow only goes part way up the upper arm. I could run one shadow from the shoulder right down to the inside of the elbow, but this wouldn't show the conformation and muscle structure of the upper arm. Now I add the rest of the shadows around the head. I combine the hair and cast shadow over the upper arm.

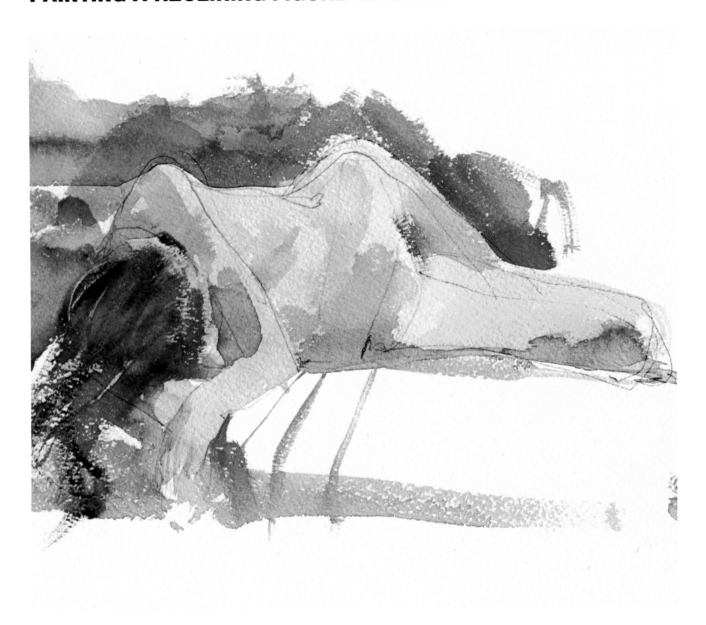

Step 3. Since the whole lower torso forms a plane turned from the light, I indicate slightly cooler, darker washes here. I also show the left breast in a plane away from the light. I add shadow to the right leg. I apply each wash with deliberation. The result should look spontaneous, but there's nothing spontaneous about my thinking. I add shadow features to the head and brush in more of the background.

PAINTING A RECLINING FIGURE INDOORS

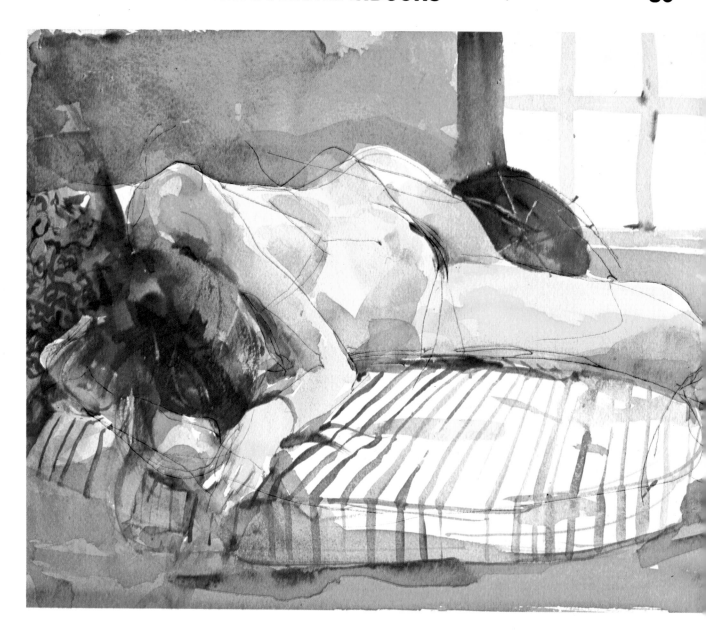

Step 4. I finish the background before going on with the figure. When the background is complete, I add a few more minor washes and value changes to the figure. Notice that I've left many hard edges within the figure. I like this quality, although I could have softened and polished the figure with successive, subtle graded washes for a different effect.